Water St

GASTOWN

PAUERU GAI

Alexander St

Powell St

Cordova St

DOWNTOWN EASTSIDE

Hastings St

Pender St

Shanghai Alley

CHINATOWN

Keefer St

STRATHCONA

Georgia St

Columbia St

Main St Gore Ave Jackson Ave

Carrall St

Dunlevy Ave

False Creek

WHITE RIOT

志和雅音 佳俱色参

WILL IT BE
RS OR HOME
B.C. GRANULATED for $1.00
WHITE LABOR
OUR OWN COUNTRY

唐人街 CHINA TOWN

DOMINION OF CANADA
DEPARTMENT OF THE INTERIOR

PENDER WEST
CANTON
SHANGHAI
CHINESE
CARRALL

WHITE RIOT

The 1907 Anti-Asian Riots in Vancouver

HENRY TSANG

ARSENAL PULP PRESS
VANCOUVER

WHITE RIOT
Copyright © 2023 by Henry Tsang
Essays copyright © 2023 by individual contributors

All rights reserved. No part of this book may be reproduced in any part by any means—graphic, electronic, or mechanical—without the prior written permission of the publisher, except by a reviewer, who may use brief excerpts in a review, or in the case of photocopying in Canada, a licence from Access Copyright.

ARSENAL PULP PRESS
Suite 202 – 211 East Georgia St.
Vancouver, BC V6A 1Z6
Canada
arsenalpulp.com

The publisher gratefully acknowledges the support of the Canada Council for the Arts and the British Columbia Arts Council for its publishing program, and the Government of Canada and the Government of British Columbia (through the Book Publishing Tax Credit Program) for its publishing activities. The author thanks the British Columbia Arts Council for the support of this publication.

Arsenal Pulp Press acknowledges the xʷməθkʷəy̓əm (Musqueam), Sḵwx̱wú7mesh (Squamish), and səl̓ilwətaʔɬ (Tsleil-Waututh) Nations, custodians of the traditional, ancestral, and unceded territories where our office is located. We pay respect to their histories, traditions, and continuous living cultures and commit to accountability, respectful relations, and friendship.

"Uprooting the Racism in Our Ranks: Reflections from a Labour Perspective" was originally published in *The Monitor*, May/June 2022.
"An Urban Rights Praxis of Remaining in Vancouver's Downtown Eastside" is an updated excerpt from an article published in *Environment and Planning D: Society and Space* 38, no. 2 (2019).

Cover and text design by Jazmin Welch
Front cover photo: 122 Powell Street, Vancouver. An image from Stop 9 of the 360 video walking tour *360 Riot Walk*, 2019, by Henry Tsang | *360 Riot Walk*
Back cover photo: The southeast corner of Hastings Street and Columbia Street after the anti-Asian riots of 1907. | University of British Columbia Library, Chung Collection, Vancouver, CC_PH_00230
Frontispiece: Shanghai Alley, Vancouver. An image from Stop 7 of the 360 video walking tour *360 Riot Walk*, 2019, by Henry Tsang. | *360 Riot Walk*
Contributor essays edited by Henry Tsang
Copy edited by Catharine Chen
Proofread by Alison Strobel
Indexed by Stephen Ullstrom

Printed and bound in Canada

Library and Archives Canada Cataloguing in Publication:
Title: White riot : the 1907 anti-Asian riots in Vancouver / Henry Tsang.
Names: Tsang, Henry, 1964– author.
Description: Includes bibliographical references and index.
Identifiers: Canadiana (print) 20220419523 | Canadiana (ebook) 20220419566 | ISBN 9781551529196 (softcover) | ISBN 9781551529202 (EPUB)
Subjects: LCSH: Riots—British Columbia—Vancouver—History—20th century. | LCSH: Racism against Asians—British Columbia—Vancouver—History—20th century. | LCSH: Asians—British Columbia—Vancouver—Social conditions—20th century. | LCSH: Vancouver (B.C.)—Race relations.
Classification: LCC HV6485.C32 V357 2023 | DDC 303.6/23097113309041—dc23

Southeast corner of Hastings Street and Columbia Street after anti-Asian riots of 1907. | University of British Columbia Library, Chung Collection, Vancouver, CC_PH_00230

Contents

9 **Foreword**
Patricia E. Roy

23 **Introduction**
Henry Tsang

29 **Where You Are Standing:**
The Embodied History of *360 Riot Walk*
Henry Tsang

61 ***360 Riot Walk* Script**
Michael Barnholden and Henry Tsang

109 **Uprooting the Racism in Our Ranks:**
Reflections from a Labour Perspective
Stephanie Fung, Anna Liu, karine ng 吴珏颖, and Chris Ramsaroop

119 **Why We Say Powell Street and Not "Japantown"**
Angela May and Nicole Yakashiro

129 **The Bellingham Riot**
Paul Englesberg

141	**A Changing Chinatown:** **On Gentrification and Resilience**
	Melody Ma 馬勻雅

149	**Census Making and City Building:** **Data Perspectives on the 1907 Anti-Asian Riots** **and the Development of Vancouver**
	Andy Yan

167	**An Urban Rights Praxis of Remaining** **in Vancouver's Downtown Eastside**
	Jeffrey R. Masuda, Aaron Franks, Audrey Kobayashi, Trevor Wideman, and the Right to Remain Research Collective

179	Acknowledgments
181	Works Cited
184	Further Reading
186	Index
190	About the Contributors

Foreword

PATRICIA E. ROY

Thanks to modern technology and historical research, it is possible to recreate, at least in part, images of events that took place many years ago. The video walking tour *360 Riot Walk* illustrates how such a reconstruction can stimulate thinking about an embarrassing past and its relevance to the present. This tour also reveals how a distinctive area of Vancouver has retained some characteristics of 1907 and yet continues to change.

THE ORIGINS OF CHINATOWN AND POWELL STREET

Several essays rightly refer to the First Peoples of this land: the Squamish, Musqueam, and Tsleil-Waututh. By the time the city of Vancouver was created in 1886, most of their lands had been usurped, and they largely resided on reserves at Kitsilano, Musqueam, and Capilano across Burrard Inlet. A few resided at an "Indian rancherie" east of Hastings Mill at the foot of what is now Dunlevy Street. The sawmill, which began operating in the mid-1860s, employed a number of Squamish and Musqueam men, some of whom held highly skilled positions or worked as longshoremen, a trade in which they remained prominent.[1]

First Nations people encamped on Alexander Street beach, at the foot of Columbia Street, ca. 1898. | City of Vancouver Archives, IN N12

1 Rolf Knight, *Indians at Work: An Informal History of Native Indian Labour in British Columbia, 1858–1930* (Vancouver: New Star, 1978), 124ff; Knight, *Indians at Work*, 2nd ed. (1996), 233–234; Robert A.J. McDonald, *Making Vancouver: Class, Status and Social Boundaries, 1863–1913* (Vancouver: UBC Press, 1996), 8–9.

The Hastings Mill also attracted Chinese workers. Chinese men first came to British Columbia with the gold rush that began in 1858. Many left as the gold rush faded, but an estimated sixteen thousand arrived in the early 1880s to help build the Canadian Pacific Railway (CPR).[2] As the railway neared completion, many workers left, but some found employment at the Hastings Mill.[3] By the end of 1886, a small Chinatown with a population of about ninety was established on Dupont Street (now East Pender), west of Westminster Avenue (now Main Street).[4] At that time, the tidal flats of False Creek extended inland into what is now the rail yard adjacent to Pacific Central Station. The city, anxious to get land cleared, leased sixty hectares (160 acres) of forested land on Westminster Avenue just north of False Creek to a group of Chinese on the condition that they clear and cultivate it. Their vegetables helped to feed Vancouver. An anti-Chinese riot in 1887 drove most Chinese residents from the city, but only briefly.[5] By 1892, a Chinatown with a variety of shops and services catering to its residents had formed on higher ground around Hastings and Carrall Streets.[6] The location was convenient to the sawmills and shingle mills then emerging along False Creek; to the docks from which steamers took seasonal workers to coastal fish canneries; and to the BC Electric Railway at Hastings and Carrall, which by 1891 ran interurban trains to New Westminster and by 1905 to the fishing community of Steveston.

◀

Chinese fish peddlers at the waterfront, near the foot of Carrall Street, 1904. | Photo: Philip Timms. Vancouver Public Library, 8005

2 The exact number is unknown. The most recent scholarship on the subject reports that likely over twenty thousand Chinese arrived at BC ports between 1880 and September 1885 and suggests that at least ten thousand worked on railway construction (Zhongping Chen, "The Construction of the Canadian Pacific Railway and the Transpacific Chinese Diaspora, 1880–1885," in *The Chinese and the Iron Road: Building the Transcontinental Railroad*, eds. Gordon H. Chang and Shelley Fisher Fishkin [Stanford: Stanford University Press, 2019], 298).
3 Paul Yee, *Saltwater City: An Illustrated History of the Chinese in Vancouver* (Vancouver: Douglas & McIntyre, 1988), 21.
4 David Chuenyan Lai, *Chinatowns: Towns Within Cities in Canada* (Vancouver: UBC Press, 1988), 79.
5 Yee, *Saltwater City*, 24.
6 Kay Anderson, *Vancouver's Chinatown: Racial Discourse in Canada, 1875–1980* (Montreal and Kingston: McGill-Queen's University Press, 1991), 68.

Transportation facilities and employment opportunities also attracted the Japanese who began arriving around 1892. Some found employment at Hastings Mill, which they called *otasuke geisha*, or "saviour company," because it often provided jobs when no other work was available.[7] In time, the Japanese dominated the mill's workforce. Like the Chinese, they accepted lower wages than white men, but their "bosses" convinced management that they were more efficient workers than the Chinese.[8] Powell Street, a block away, provided accommodation, entertainment, and services, including employment agencies that supplied workers to a variety of industries. During an economic depression in the mid-1890s, some white merchants went bankrupt, and Japanese businessmen acquired property there.[9] By 1907, Powell Street, or Paueru Gai, was a well-established neighbourhood.[10] Outsiders referred to it as "Little Tokyo" even though most of its Japanese residents came from rural and semirural areas in the southwestern prefectures of Japan, and not all of its residents were Japanese.

To the west of Chinatown was the so-called "Skid Road," named initially after the rough trails over which logs were hauled to the waterfront. In many cities, including Vancouver, it became the nickname for an impoverished neighbourhood. Seasonally unemployed workers of many ethnic backgrounds congregated there and patronized its inexpensive accommodations, amusement places, employment agencies, and stores selling such specialities as loggers' boots and fishermen's slickers.

Large timbers being loaded onto flatcars at Hastings Mill, 1925. | *Photo: Leonard Frank. Vancouver Public Library, 3653*

[7] Michiko Midge Ayukawa, *Hiroshima Immigrants in Canada, 1891–1941* (Vancouver: UBC Press, 2008), 12–13.
[8] Audrey Kobayashi, *Memories of Our Past: A Brief History and Walking Tour of Powell Street* (Vancouver: NRC Publishing, 1992), 46.
[9] Kobayashi, *Memories*, 14.
[10] The Japanese were not recorded in the 1901 federal census. According to the 1911 census, of the 8,578 Japanese in British Columbia, 2,036 were residents of Vancouver, but the population varied seasonally according to the demand for labour in outside industries (Charles H. Young and Helen R.Y. Reid, *The Japanese Canadians* [Toronto: University of Toronto Press, 1938], 68).

WHY A RIOT?

Why did a mob riotously attack the Chinese and Japanese quarters of Vancouver on a sultry Saturday night in September 1907? The complex answers overlap. What follows is a very simplified explanation. Some causes were long-term and not unique to Vancouver; others were triggered by events specific to time and place.

Whenever people from China, Japan, or India crossed the Pacific to North America and Australasia, they encountered hostility from white settlers, mostly relative newcomers themselves, who had already displaced the Indigenous Peoples. Today, "race" is recognized as a constructed concept, but that was not always so. In the nineteenth century and well into the twentieth, many white people believed in a racial pecking order in which they stood at the top. Yet, there were paradoxes in their thinking. One of their concerns was the speed with which Japanese, with superior skills and work habits, came to dominate the Fraser River fishing industry.

A major argument against Asians was a fear that if immigration were not checked, the "huge" populations of China, Japan, and India could overwhelm white communities. The United States banned Chinese immigration in 1882; Canada imposed a head tax of fifty dollars on Chinese in 1885 and increased it to five hundred in 1903; and a language test kept Australia "White." Because Japan controlled emigration and Canada was bound by the Anglo-Japanese Alliance of 1902 and various commercial treaties, Canada did not initially restrict Japanese immigration. Moreover, during the Russo-Japanese War of 1904–05, there was almost no immigration from Japan to Canada. Japan's victory in that war confirmed its status as an international power.

In addition, there were moral objections to the Asian presence. Emigration customs in Asia, as in Europe, frequently saw men go abroad to earn money. Because of this and restrictions on immigration, Asian residents were overwhelmingly male. Such men often found recreation in gambling, an illegal practice that was deemed immoral. Chinese men were known for smoking opium, a practice considered immoral and dangerous to white youth, but not illegal. Some men patronized houses of ill repute on Dupont Street in Chinatown. And, not least of all, if Asians and whites intermarried, some feared that miscegenation would produce inferior human beings.

Much of the argument against Asians was economic. Asians often had little choice but to accept lower wages than white men for similar work. Moreover, contractors within both the Chinese and Japanese communities hired work crews, ensured that the requisite number were on duty each day, collected a single paycheque from the employer, and paid individuals after taking a cut for themselves. White men complained that by living cheaply, Asians did not contribute to the local economy as consumers. Many Asian men sent money to family at home and aspired to be sojourners who would eventually return home, where their overseas savings would go far. Living cheaply, especially for the Chinese, often meant living in overcrowded quarters that outsiders deemed a danger to public health. Conditions in the Japanese lodging houses were probably no better[11] but did not draw the same degree of attention from the larger community.[12]

A major explanation for the outbreak in September 1907 was an increase in immigration from Asia and rumours of more arrivals. The

"The same act which excludes Orientals should open wide the portals of British Columbia to white immigration," cartoon by N.H. Hawkins in Saturday Sunset, *August 24, 1907.*

11 Ken Adachi, *The Enemy That Never Was: A History of the Japanese Canadians* (Toronto: McClelland & Stewart, 1976), 47.
12 Patricia E. Roy, *A White Man's Province: British Columbia Politicians and Chinese and Japanese Immigrants, 1858–1914* (Vancouver: UBC Press, 1989), 32.

five-hundred-dollar head tax had sharply reduced immigration from China, but more Chinese seemed to be arriving in the spring and summer of 1907—although many were actually established residents returning from visits to China. Nevertheless, between July 1907 and March 1908, the Canadian government collected the head tax from more than two thousand Chinese immigrants, not all of them destined for Vancouver.[13] The drop in Chinese immigration created an opportunity for immigrants from Japan and India. After the Russo-Japanese War, Japan eased emigration regulations. Only a handful arrived in 1905–06, but about two thousand arrived in each of 1905–06 and 1906–07, and almost 5,600 arrived in the first seven months of 1907.[14] Immigration from India rose from being negligible to over two thousand in each of 1906–07 and 1907–08.[15] Although most immigrants from India worked in the lumber industry and in agriculture outside of Vancouver and were not immediately affected by the riot, their increasing presence was noted.[16] In the iconic photograph of the broken windows of a Japanese grocery store, the man wearing a turban was likely only a passerby.

Anti-Chinese organizations had existed in British Columbia since the late 1870s, but all were short-lived. In the summer of 1907, the Vancouver Trades and Labour Council was aware of similar organizations along the US Pacific Coast. It invited representative politicians and others to a founding meeting of the Asiatic Exclusion League. The League did not generate the popular enthusiasm expected by its founders, so they organized a parade and a rally at the city market building for the evening of September 7, 1907. Featured speakers included two

Damage to 130 Powell Street, 1907. | Library and Archives Canada, Ottawa, C-014118

13 Roy, *A White Man's Province*, 270.
14 Roy, *A White Man's Province*, 186.
15 Norman Buchignani, Doreen M. Indra, and Ram Srivastiva, *Continuous Journey: A Social History of South Asians in Canada* (Toronto: McClelland & Stewart, 1985), 7.
16 Buchignani, Indra, and Srivastiva, *Continuous Journey*, 22.

Asiatic Exclusion League of BC membership card, 1921. | Photo: Nick Procaylo. University of British Columbia, Chung Collection, Vancouver

leaders of the anti-Asian movement in Seattle, one from New Zealand, two local clergymen, and two prominent local politicians. A few days earlier, the Seattle visitors had been at the Bellingham riot.

The crowd at the meeting hall overflowed into the street, so several speakers came outside to repeat their arguments for a ban on Asian immigration to preserve "pure Anglo-Saxon blood" and to stop cheap labour. The crowd became a mob after someone called for a march on Chinatown, little more than a block away. After breaking windows and terrorizing the population there, the mob carried on to Powell Street, where the Japanese, who had some advance warning, were better able

"Chinese Buy Revolvers for Defence in Case of Riots," front page of Vancouver Daily Province, *September 9, 1907*

to defend themselves but not to escape property damage. On Sunday night, a smaller mob descended on Chinatown and Powell Street, where the well-prepared residents largely repelled them. Fortunately, on neither night was there a loss of life. The Japanese community showed its militancy; the Chinese demonstrated their importance to the city over several days by withdrawing their services as domestic servants and as hotel, restaurant, and laundry workers.[17]

THE AFTERMATH

The immediate response was embarrassment. Vancouverites erroneously blamed Americans for the riot. Nationally, Canada desired to increase trade with its ally, Japan. The embarrassed federal government of Wilfrid Laurier quickly arranged to send Rodolphe Lemieux, the minister of labour, to Japan to negotiate an immigration agreement with Japan. Under the resulting Hayashi-Lemieux agreement, or Gentlemen's Agreement, Japan limited the number of passports that it would issue to people wanting to emigrate to Canada. This did not affect family members of Japanese already in Canada. As many of the *Issei*, first-generation Japanese immigrants, had established themselves, they sent for their wives or for "picture brides," women they may not have previously met. After proxy marriage ceremonies, the women entered Canada as wives. The Japanese population soon rose as the result of a temporarily high birth rate.

The Gentlemen's Agreement contained a loophole whereby Japanese who had migrated to Hawaii did not fall under Japan's jurisdiction. In response, Canada enacted the "continuous voyage" policy, requiring immigrants to come directly from their country of origin. Not only

17 Roy, *A White Man's Province*, 190–193.

did that end Japanese immigration from Hawaii, but it also halted immigration from India, because no ships sailed directly from India to Canada. Meanwhile, in a booming economy, wages rose, and the five-hundred-dollar head tax became less of a deterrent to the Chinese. As immigration from China continued, so too did pressure for an end to it. Thus, in 1923, the Government of Canada passed a new Chinese Immigration Act which, until it was repealed in 1947, almost completely stopped immigration from China.

The Laurier government also sent William Lyon Mackenzie King, the deputy minister of labour, to Vancouver to investigate claims for damage to Japanese property and to arrange compensation. His time in Vancouver inspired his further studies of methods by which "Oriental labourers" had been recruited and the need to suppress the opium trade. He eventually arranged compensation for damage to Chinese property. King did not forget the riot. Early in 1942, he believed warnings from many prominent British Columbians that if the Japanese, including those Canadian born, were not immediately removed from the coast, there would be riots. A few days before the Cabinet ordered the removal of all people of Japanese origin from the coast, he recorded in his diary, "It is going to be a very great problem to move the Japanese and particularly to deal with the ones who are naturalized Canadians or Canadian born. There is every possibility of riots."[18] The departure of the Japanese broke up the Powell Street community but did not permanently destroy it.

[18] William Lyon Mackenzie King, *The Diaries of William Lyon Mackenzie King* (Ottawa: Library and Archives Canada, 2006), February 19, 1942, entry.

THE SCENE TODAY

Today, Powell Street and Chinatown lie within the Downtown Eastside, whose postal code, V6A, is one of the poorest in Canada. It has a reputation for crime, inadequate housing, addiction, mental illness, violence, and overall poverty, and is a place where personal safety is a concern for both vulnerable residents and visitors.

At the same time, gentrification has come to the neighbourhood. As old buildings are replaced or redeveloped, rents rise—usually beyond the means of current residents. New buildings and businesses also challenge cultural institutions and landmarks. Yet, there has been resistance to change, with the best example being the pressure in the late 1960s that halted plans to run a freeway through a part of Chinatown. More recently, local protesters prevented the construction of a high-rise condominium that would overwhelm such cultural markers as the monument commemorating the Chinese who built the CPR or who fought with the Canadian Armed Forces. Similarly, the city's plans to "beautify" what its planners called "Japantown" met with protests from local residents.

While open racism is generally abhorred today and discriminatory laws were long ago repealed, racism has never fully disappeared and can be easily aroused, as, for example, in the rise of racist incidents when COVID-19 was mislabelled "the Chinese disease." Learning about the "other" and appreciating their histories is one of the best ways of combatting racism. Let us hope that this virtual tour, by introducing people to this area, its history, and its residents, will contribute to the demise of that evil.

◀

White Canada Crusade *pamphlet, 1900.* |
*University of British Columbia Library,
Chung Collection,* CC-TX-100-4-2

Introduction

HENRY TSANG

White Riot: The 1907 Anti-Asian Riots in Vancouver is based on *360 Riot Walk*, a 360 video walking tour that traces the history and route of the mob that attacked the Chinese Canadian and Japanese Canadian communities following the demonstration and parade organized by the Asiatic Exclusion League in Vancouver. Participants are led into the social and political environment of the time, where racialized communities were targeted through legislated acts, as well as physical acts of exclusion and violence.

The interactive tour can be accessed on any web browser via the site 360riotwalk.ca—on location with a mobile device such a smartphone or tablet, or remotely on a desktop computer. The soundtrack is available in four languages spoken by the local residents at the time: English, Cantonese, Japanese, and Punjabi. Each voice-over includes an introduction in Sḵwx̱wú7mesh Sníchim, one of the two Indigenous languages of the area (the other being hən̓q̓əmin̓əm̓), as the events occurred on the unceded land of the Sḵwx̱wú7mesh (Squamish), xʷməθkʷəy̓əm (Musqueam), and səlilwətaʔɬ (Tsleil-Waututh) Nations.

360 Riot Walk is a documentary, a mapping project, and an artwork. As a documentary, it tells the story not only of the 1907 riots, but also of the rise of anti-Asian sentiment that preceded it and the aftermath of subsequent restrictions against Asian immigration that were enacted.

◀
360 Riot Walk *guided tour participants, 2019.* | *Photo: Henry Tsang*

Asiatic Exclusion League

A public meeting will be held in the Auditorium of Labor Hall MONDAY, AUGUST 12, at 8 p. m., for the formation of an Asiatic Exclusion League in this city

All the local members of the Legislature and the Dominion member for this city have been invited to attend and address the meeting

◀

Advertisement in Vancouver Daily Province, *August 10, 1907.*

As a mapping project, it traces the founding of the Asiatic Exclusion League's Vancouver chapter and how its racist histrionics incited an angry white mob to riot in Chinatown and Powell Street for over two days. As an artwork, it is an immersive video that employs cutting edge technology, albeit with a lo-fi approach, akin to a site-specific interactive slide show accompanied by a voice-over, with the imagery responding to your body's movements.

This book is a continuation of the journey that the walking tour has taken, circling back to the original English script, co-written by Michael Barnholden and me. I have included a reflective essay chronicling the process and challenges of the making of the artwork, as well as other projects that preceded and informed it. There are visual excerpts of the panoramic photographs from each of the thirteen tour stops, archival images and documents embedded into the 360 photos, and photodocumentation of guided tours.

Perhaps most significant are the essays by contributing writers, which provide a more detailed contextualization of some issues of the time and their impact on our lives today. I am honoured that historian Patricia E. Roy has provided the foreword to this book. Her book *A White Man's Province* (1989), with its insightful and incisive investigation into the propagation of racist attitudes and exclusionary practices and policies, has been an influential text for me ever since I began researching what it means to be Chinese in this place that I call home. In their essay, "Uprooting the Racism in Our Ranks: Reflections from a Labour Perspective," Asian Canadian Labour Alliance members Stephanie Fung, Anna Liu, karine ng 吴珏颖, and Chris Ramsaroop provide a contemporary perspective on anti-Asian violence in Canada, which has increased significantly since the COVID-19 pandemic, and calls out for organized labour to confront and stop this spreading of hate. Angela May and Nicole

East Indian immigrants at the CPR pier loading possessions onto horse-drawn wagons, ca. 1910. | *Photo: George Barrowclough. Vancouver Public Library, 9426*

Yakashiro's "Why We Say Powell Street and Not 'Japantown'" considers the politics of place and the power of names in Vancouver's Powell Street (Paueru Gai) neighbourhood and how a name like "Japantown" can, ironically, precipitate displacement in the very neighbourhood from which Japanese Canadians were forcibly removed during the Second World War. Paul Englesberg's "The Bellingham Riot" focuses on the agitation and violence against South Asians in the Washington state mill town that took place three days prior to Vancouver's own riot and how widespread such attacks were along the West Coast in 1907. Melody Ma's 馬匀雅 "A Changing Chinatown: On Gentrification And Resilience," explores the history of Vancouver's historical Chinatown, its roots in anti-Chinese exclusion, and the present-day threat of gentrification that is eroding the neighbourhood's cultural identity. Andy Yan's "Census Making and City Building: Data Perspectives on the 1907 Anti-Asian Riots and the Development of Vancouver" looks at how the Census was used not as a neutral tool of quantitative measurement, but as a socially constructed measure that reflected the ideas and values of the toolmakers. He posits that the Census was and still is a contested space used to determine who is and who is not considered a Canadian and who belongs to the city. And Jeffrey R. Masuda, Aaron Franks, Audrey Kobayashi, Trevor Wideman, and the Right to Remain Research Collective's "An Urban Rights Praxis of Remaining in Vancouver's Downtown Eastside" examines 150 years of colonial policies of racial containment in Vancouver's Downtown Eastside through their research project, which involves past and present members of this community voicing their experiences in the pursuit of resistance to those very policies. I am indebted to the contributing writers for their patience and openness throughout the editorial process. The wealth and depth of their knowledge and lived experience is evident in the writings they have created for this publication.

360 Riot Walk was launched on July 27, 2019, at the Dr. Sun Yat-Sen Classical Chinese Garden, which was the project's lead collaborator and host. The first guided tours took place the following week at the Powell Street Festival. Community partners included the Japanese Language School and Japanese Hall, the Chinese Canadian Historical Society of BC, the Carnegie Community Centre, and Project 1907. Funding for production and development of the tour was provided by Creative BC and the BC Arts Council, the City of Vancouver's Neighbourhood Matching Fund, and a Social Sciences and Humanities Research Council Explore Grant through Emily Carr University of Art + Design, where I teach. Development of this book was made possible through the financial assistance from the BC Arts Council.

In 2020, the 360 tour was significantly revised with upgraded visual elements and a new website, with updated instructional videos, commissioned writings, and additional resources. In 2021, the Powell Street Festival took on stewardship of the guided tours, for which I am grateful, as they are the ideal partner, given that their ongoing commitment to the Downtown Eastside community has been consistently progressive and, perhaps most importantly, courageously and radically inclusive.

▲
Stop 2: Carrall Street and East Hastings Street. | 360 Riot Walk

Where You Are Standing: The Embodied History of *360 Riot Walk*

HENRY TSANG

"Where you are standing …" is the first thing you hear in the voice-over at the beginning of *360 Riot Walk*, because it was there, on the very ground under your feet, where the 1907 anti-Asian riots took place. Standing there, you can see, hear, feel, smell, and taste the reality of the present while projecting yourself into the past, bearing witness to the events that created a lasting impact still evident today.

How things have changed since then. And yet, some other things haven't. In *360 Riot Walk*, buildings around you are plastered with posters promoting white nationalist ideologies which may be from a century past, but some of these ideals are still alive today and, for some, just as urgent. When you are standing on what was once the site of racist violence, does your relationship to this place change? Do you feel implicated, ashamed, indignant, complicit? If you had been on the streets of Vancouver on September 7, 1907, would you have joined the parade organized by the Asiatic Exclusion League and the Vancouver Trades and Labour Council? Would you have gathered at City Hall to cheer on the speeches by politicians, labour organizers, and Christian leaders outraged by the presence of Asian people in their city? Would you have been swept up by the energy of the crowd and marched toward Chinatown to attack Chinese people and their homes and businesses, then on to Powell Street, where the Japanese lived? Would you have been

> **WILL BE BUMPER ANTI-BROWNIE PARADE**
>
> Three Thousand Anti-Asiatics Expected to March Streets of City To-night to the City Hall.
>
> It is expected that there will be at least three thousand members and friends of the Asiatic Exclusion League in the

> **For Your CHILDREN'S SAKE**
> VOTE THE
> **Asiatic Exclusion League Ticket**
> ON THURSDAY.
> GOOD MEN AND A GOOD CAUSE
> WARD 1—J. W. Prescott.
> WARD 2—Ald. D. M. Stewart, Ald. Campbell.
> WARD 3—E. S. Knowlton, Ernest Burns.
> WARD 4—Ald. Geo. McSpadden.
> WARD 5—John Morton.
> WARD 6—John McMillan.
> License Commissioner—Geo. F. Macdonald.
> SCHOOL TRUSTEES
> C. E. Hope, W. E. Flumerfelt, Chas. Hilton, Wm. Clubb.

TOP: *Article on front page of* Vancouver Daily Province, *September 7, 1907.*

BOTTOM: *Advertisement for a meeting to discuss formation of an Asiatic Exclusion League in* Vancouver Daily World, *January 8, 1908.*

dreading the widely publicized parade and demonstration, or would you have ignored it, hoping that it would just go away? Would you have wondered whether you should leave town in case violence erupted yet again, or stay and protect yourself, your family? Would you have gone into the streets to defend your community? Would you have armed yourself? Would you have felt helpless or angry, defiant or defeated?

360 Riot Walk is an artwork in the form of a walking tour that employs 360 video technology. It is akin to a documentary film, except that it is interactive and asks the audience not only to participate in the viewing of the piece, but also, in its ideal mode of experience, to move through the same space where these events took place.

Much of my work and, indeed, much of my life has been spent pondering and attempting to articulate my position in this city called Vancouver, which I have the privilege to call home. Many of my projects, although not all, are in some way an exploration of the nexus of the relationships and histories, peoples and capital, languages and cultures of a particular place. These situations and conditions at times coexist and overlap, and at other times, grate aggressively against each other.

Growing up, I often wondered what life would have been like if my family had immigrated from Hong Kong to Canada earlier. We would not likely have come during the head tax era—certainly not when the Chinese Immigration Act of 1923, also known as the Chinese Exclusion Act, which effectively halted Chinese immigration to Canada until 1947, was in effect; nor prior to the immigration regulations introduced in 1967, with which Canada finally attempted to address its history of racial discrimination. So 1968 was a good year to move to Canada, from one part of the British colonial empire that had been ceded in a treaty resulting from the First Opium War to another that is still unceded,

the land of the xʷməθkʷəy̓əm (Musqueam), Sḵwx̱wú7mesh (Squamish), and səl̓ilwətaʔɬ (Tsleil-Waututh) Nations.

Part of the impetus for creating *360 Riot Walk* came from my wondering what it would have been like to be in Vancouver during the 1907 riots. I didn't learn about this significant event while growing up here, nor was I ever taught in school about the internment of the Japanese Canadians, Italians, Ukrainians, and others during World War II, nor the Indian Act, nor the disenfranchisement of Indigenous and Asian people in Canada. As kids, we learned about women gaining suffrage, but our educators neglected to clarify *which* women—or perhaps more accurately, who qualified.

The script was written by me and Michael Barnholden, author of *Reading the Riot Act: A Brief History of Riots in Vancouver* (Anvil Press). Initially, I asked Michael to adapt his chapter on the riots for this project, but after initial discussions, it became clear that I wanted more, that, in his words, this was to be a story about white supremacy in British Columbia. So we collaborated.

As we both delved further into the background surrounding this event, we discovered that since the publication of his book in 2005, more historical information had become accessible, partly due to the digitization of archival materials. We attempted to include more than one perspective in the telling of the many stories that led up to and were subsequently affected by this event. It was important to identify parts of the city that remain to this day, as a way of physically situating the participant in this landscape to provide background to some of the buildings and the area that are rich with history. It was doubly important to reach beyond that surface and expose some of the conditions in which people inhabited these spaces, what the social, cultural, and political climate was like depending on what kind of person you were,

"The Heathen Chinee in British Columbia," illustration by James L. Weston in Canadian Illustrated News, *April 26, 1879.*

how you were identified, and, as a result, the rights and privileges you had access to, or not.

Through the Dr. Sun Yat-Sen Classical Chinese Garden, workshops were organized with support from the Japanese Language School and Japanese Hall, the Chinese Canadian Historical Society of BC, and the Carnegie Community Centre, reaching out to local organizations and elders to ask whether anyone had any relatives who talked about the 1907 riots. Some respondents shared stories about their grandfathers' experiences. In one case, a Powell Street resident had fought alongside his neighbours to protect his neighbourhood, but fearing a larger attack the following day, he and some others left the area and took a boat to Steveston, the fishing village where there was another sizable Japanese population, hiding out until the battles had subsided. Another story involved being attacked by white men while out walking in Chinatown and being hung by his queue on a telephone pole. A few days later, he saw the same men coming out of a building. He then beat them up and dragged them to the police station, but nothing came of it. In general, Chinese people were afraid to go outside of Chinatown for fear of being beaten, especially after the riots.

I wanted to include the linguistic and cultural backgrounds of those who were active in or implicated by this event, and so the English script would be translated into the three other main languages spoken in the area in 1907: Cantonese, Japanese, and Punjabi. But which dialects? There were many dialects of Cantonese spoken in and around Chinatown, the most common being those from Taishan 臺山 and Zhongshan 中山. But if the voice-over was in Taishan 臺山 dialect, it would be unintelligible to virtually all other Cantonese speakers, including me. For Punjabi and Japanese, we faced the same predicament, as similarly, those early immigrants did not all come from the same region. In the end, I decided

on the standardized versions of these languages in order to make the translations as accessible to as many speakers as possible.

A fifth language was also included: Squamish, or Sḵwx̱wú7mesh Sníchim, which is one of the two Indigenous languages of the area, the other being hən̓q̓əmin̓əm̓. Unfortunately it was not possible to translate the entire script due to capacity—Squamish and hən̓q̓əmin̓əm̓ translators are in high demand, and there are few available. So the Squamish version is relatively brief, functioning as a welcome to the tour and to this land where the language has been spoken for millennia. Situated within the first stop for each of the four soundtracks, it is omnipresent in the tour.

Then there were the actual translations themselves. As Jacques Derrida famously wrote, translation is impossible. More specifically, it is impossible for words, and thereby meaning, when moving from one language to another, to remain the same—translation is inherently an act of transformation. It is a struggle to retain sameness in the original meaning, especially when that original meaning is in itself not fixed but open for interpretation. Although the script was straightforward prose and did not pose the challenges that poetry might and should, there were certainly subtleties with culturally and contextually specific details and references that caused the translators to conduct further research and, in some cases, confront existential dilemmas. When it was time to record the voice-overs, it was exciting and informative for me to be privy to the intense discussions between the translators and translation script editors, debating particular words and phrases and in what context something might be said, read, or interpreted. Editing the soundtracks was quite the experience, for I didn't understand Japanese, Punjabi, nor much Cantonese (and still don't). I am indebted to the translators for their generosity and patience.

360 RIOT WALK
WALKING TOUR STOPS

1. Carrall & Water
2. Carrall & Hastings
3. 139 East Hastings
4. 438 Main
5. Main & Pender
6. Pender & Carrall
7. Shanghai Alley
8. Pender & Columbia
9. Across from 122 Powell
10. 245 Powell
11. 374 Powell
12. Across from 467 Alexander
13. Across from 439 Powell

Importantly, I wanted to make this project accessible to recent immigrants who might not be aware of this historic event, encouraging them to reflect on what their lives might have been if they had come to this part of the world at a slightly earlier time. The symbolism of choosing these languages, however, continues to be a point of contention for some participants who see the omission of Mandarin and French to be missed opportunities for further outreach. If we were to reflect and address our current demographic, I would argue that Spanish should also be included. However, these languages were not commonly in use a century ago in Vancouver, and thereby lie beyond the conceptual framework of the project.

In determining what route the tour would take, Michael and I grappled with the logistics of retracing the steps taken by the parade organizers and subsequently the rioters. The crowd assembled at the Cambie Street Grounds, now Larwill Park in downtown Vancouver, and made their way through the central business district to the Old Market Hall, where City Hall was located at the time. We decided not to begin the tour at the parade's origin, as it is quite a distance from City Hall, but in historic Gastown, which is closer. We also wanted to establish the setting of this British settler space in its early days so as to identify some of the local landmarks that are still standing and to introduce some of the conditions and legislations that contributed to the political and racial climate of the time.

After City Hall, we made the decision to avoid Market Alley, even though that was where the mob first marched on their way to attack the Chinese. For the past decade and more, this laneway and others in Vancouver's Downtown Eastside have been sites where opioid consumption is openly practised. We decided to bypass this location, not only out of concern for the safety of the tour participants who would

◀

Locations of the 360 Riot Walk *stops.*

have needed to avoid stepping on spent syringes, but also out of consideration for those with addiction disorders, who have few other places to use substances aside from marginalized spaces such as these. It is particularly ironic that the beginning of Canada's war on drugs can be traced to William Lyon Mackenzie King's Royal Commission report on the 1907 riots. During his inquiry, he first learned of the opium factories operating in Market Alley; this in turn led to his drafting the Opium Act in 1908.

360 Riot Walk was my first foray into 360 video technology. Although I had previously worked with video and experienced various virtual reality (VR) and augmented reality (AR) projects, I soon learned that making something in surround sight and sound required a significant shift in approach. In traditional filmmaking, the point of view can shift from third person (a fly-on-the-wall perspective) to first person (through the protagonist's eyes, say) to second person (someone responding to that protagonist). Camera movements such as tracking, dollying, and zooming can be used to create a sense of moving through space or to expose something revealing. Editing plays a key role in shifting perspective or location or time. Other formal devices that augment the power of editing are framing devices such as the wide, medium, and close-up shots. Controlling what, as well as how, the viewer sees is an indelible part of cinematic language and strategy. But in a 360 production, the viewer is in greater control of what they see. Editing is used more sparingly, for any change of location can be jarring, as if one's entire body has been transported into a new space, requiring a period of reorientation, of settling in. Audio, which often plays a supportive role to visuals in cinema, takes prominence as it becomes more influential. The viewer is now even more of a listener, and the soundtrack has the power to direct

Adiba Muzaffar on location with 360 camera. | *Photo: Arian Jacobs*

360 Riot Walk guided tour participants, 2019. | *Photo: Henry Tsang*

A 360 Riot Walk participant views a 360 image, 2021. | Photo: Henry Tsang

them to relate and connect aural information with the visual world around them.

And interactive technology creates for the user an expectation that the information or stimuli provided, whether in text, visual, aural, or other sensorial form, be made accessible, and if it's engaged with, there should be a response or outcome. In the case of a walking tour, it was crucial that there be a reason to move from one location to the next, to stop here as opposed to just anywhere, and that there be something to learn or discover along the way.

Currently, VR is most commonly experienced with 360 headsets and hand-held controllers within a rarefied space such as a gaming room, gallery, or one's home. Walking around a city requires a different approach. It's not an artificial construct—it's the real world, with real physical dangers. Incorporating AR would have required either signage such as QR codes or reliance on specific landmarks in the surrounding environment—difficult in this city, with its perpetual development that constantly replaces older buildings with taller, fancier, more expensive ones. There was also the option of using geolocation, like in Pokémon GO, but that would have required downloading a custom-made app. I wanted to make the tour as simple to access as possible. In the end, the entire project was installed on a website so that anyone with the internet could access it, whether or not they were able to physically visit the site in person.

For increased accessibility, we adapted the tour for keyboard navigation for those who are unable to operate a mouse or trackpad. The scripts in all four languages are also available on the project website, so that users who are deaf and hard of hearing can read the accompanying text for each location.

While planning the on-site walking tour, it became increasingly obvious that safety needed to be a priority. If the user were to walk along the tour route while looking at the screen of their mobile device *and* listening to the soundtrack on headphones, their sight and hearing would be isolated, and their awareness of their surroundings would be seriously compromised. If someone were to cross a street in such a state of distraction, a common phenomenon ever since the introduction of the smartphone, they would literally be an accident waiting to happen. So we decided to restrict the interactive component to each of the tour stop locations. When the user arrives at a stop, they can take their time to orient themselves and find a safe spot to stand. Then they can start that chapter by activating the gyroscope for motion response with the imagery and then play the audio voice-over. When that ends, they are given verbal directions to the next location, supported by a map and compass on the virtual ground.

This approach greatly simplified the project, for we no longer needed to shoot video. Instead, 360 photographs were taken at each of the sites where participants would stop, which we unambiguously called "Stops." Archival images and historical documents were embedded into these photographs, from the same vantage point and the same buildings where possible. In order to create a dissonance between the image on the screen and the "real" surrounding urban landscape, the 360 panoramas were rendered in black and white, a genre associated with the past. In turn, all the black-and-white archival photographs and documents were painstakingly colourized in an attempt to make them more "real" and position them within the present, appearing to exist in the same world of colour that we inhabit.

The process of colourization was itself another challenge. The easiest colour decisions were for brick buildings, utility poles, the ground, and

the sky (which we optimistically chose to be blue). But what about the buildings? We consulted the Vancouver Heritage Foundation's True Colours palette, with its thirty-five original colours used on houses and buildings in Vancouver from the 1880s to the 1920s, but as there were no colour photographs of the buildings to refer to, such a guide could only provide so much direction. In the case of the former Japanese Language School at 439 Alexander, we reached out to community members, but the old-timers couldn't recall. So the colourization of the archival images was at times an act of speculative reconstruction, much like the project overall.

Historical documents such as illustrations and caricatures were placed into the contemporary landscape as if they had been postered onto surrounding buildings. This was an attempt to physically manifest or conjure the attitudes and representations of anti-Asian sentiment, which was rampant, hyperbolic, and often hysterical in the late nineteenth and early twentieth centuries. American references were included to show that these sentiments were shared up and down the West Coast, that kindred political and social forces were at play in many places, that the white supremacist ideology embraced by those who controlled Vancouver at the time was common and normative.

Although *360 Riot Walk* was intended to be a self-guided tour, we thought that group tours led by a guide would provide a more focused experience, especially if there was an opportunity for discussion afterward. The first guided tours took place in the summer of 2019 at the Powell Street Festival, the Japanese Canadian arts and culture festival set in Paueru Gai. These were followed by tours on September 7 and 8, the anniversary of the riots, at the Carnegie Community Centre and the Classical Chinese Garden and have been offered every summer since.

◀
Stop 12: 400 Block of Alexander Street, Japanese Language School. | 360 Riot Walk

Participants are set up with a tablet and headphones and shown how to navigate the 360 video—in particular, how to line up the 360 image with the world around them, how to activate the gyroscope to have the picture on the screen respond to their movements, and how to start the audio. A guide then leads them to each of the thirteen stops, after which they adjourn to the Japanese Language School for a post-tour discussion.

The guided tours have proven to be an integral component of the project, providing a framework for those unfamiliar with the markedly distinct neighbourhoods that the participants walk through. The tour begins in Gastown, its cobblestone streets flanked by nineteenth-century brick facades fronting renovated boutiques, bistros, and design stores. Later, it moves through Chinatown, a shell of its former bustling self, with many of its storefronts shuttered due to economic malaise and struggles with the onslaught of gentrification. Then on to Powell Street, once the vibrant home of Japanese Canadians before they were forcibly moved into internment camps during the Second World War. Their property, sold off by the government to finance their own incarceration, has been replaced by nondescript concrete government buildings and social housing.

The most challenging section to navigate is the area between Gastown and Chinatown along Hastings Street, west of Main, what is often referred to as "Skid Road." The original designation for Skid Road in the 1870s was a few blocks north along Water Street, where logs were skidded down the main thoroughfare on their way to the lumber mill. Over time, "the skids" came to denote the area where the underclass and those with alcohol and drug addiction would congregate, not necessarily by choice, but because they were unwelcome anywhere else in the city. Many Vancouverites now avoid this area of Hastings, considering

Post-tour discussion at Japanese Language School and Japanese Hall, 2020. | Photo: Debbie Cheung

it dangerous and full of such "undesirable" types. As this is unsurprisingly one of the poorest areas in Canada, there is indeed plenty of visual evidence of poverty as well as homelessness and substance use on the streets. Although most of the locals on the street mind their own business, there might be some who are having a bad day and will lash out, usually verbally, at perceived outsiders.

To address any potential misperceptions, a local ambassador accompanies each tour and acts as an interlocutor for anyone on the street who might be curious about the project, assuring them that no one is taking photographs because the tablets' cameras are covered and that this is an art project they can view on one of the participants' tablets. Adding this component to the guided tours was the brainchild of the Powell Street Festival, which has a history of actively engaging in community support in the Downtown Eastside and works toward the destigmatization of local residents. They suggested working with EMBERS, a socially responsible staffing agency that specializes in providing temporary jobs to local residents. This advice proved to be invaluable, as there have been many occasions when the local ambassador not only assisted in promoting and educating the public along with the tour guide, but occasionally de-escalated situations when someone became angry and accusative, presuming that tour participants were taking photos of them.

After the tour, a facilitated discussion gives the participants the opportunity to share and compare with each other what they have just experienced. Some of the most significant moments of the tour are when participants reflect on what they have seen, heard, and walked through, crystallizing the information conveyed through the script, often evoking associations with issues we are facing in the present and raising questions about how past events have affected how things are today.

360 Riot Walk grew out of three previous projects: *Orange County, The Unwelcome Dinner*, and RIOT FOOD HERE. In 2016, I was invited by Tyler Russell, director/curator at Centre A: Vancouver International Centre for Contemporary Asian Art, to create a curated dinner. I had worked with Tyler a few years before, when my piece *Orange County* was exhibited at Centre A. *Orange County* is a four-channel video installation shot in gated communities in Orange County, California, and Orange County, Beijing, where architects and interior designers from Orange County in California were hired by a Chinese developer to create an "authentic" American-style gated community. As part of the public program, I curated a dinner within the gallery with guest speakers and chefs. The event included illuminating talks and presentations by urban planner Andy Yan, who spoke about land development in Vancouver and the city's history of creating restrictions against the Chinese from owning land; poet and food writer Gerry Shikatani, who explored the relationship between the aesthetics and gastronomics of taste; and chefs Wesley Young and Jacob Deacon-Evans, who shared their approach to making a meal from ingredients sourced within a two-block radius (in Chinatown). It was a special evening with delicious food cooked on site and lively conversation that ran late into the early hours.

Some time later, Tyler was researching Vancouver's first anti-Chinese Riot in 1887, which took place just months after the city's incorporation. White labourers travelled to Coal Harbour to drive out the Chinese crew that had been brought in to cut down trees and clear the land of what later would become the West End. The mob attacked the workers, killing one, and burned their tents and bedding. They then continued on to Chinatown, where they looted homes and set fire to buildings. Tyler wanted to build on the experience of the *Orange County* evening and

Orange County curated dinner, 2014. | Photo: Diana Klonek, courtesy of Centre A: Vancouver International Centre for Contemporary Asian Art

TOP: *Squamish dwellings on the shore of Coal Harbour, 1868. | City of Vancouver Archives, St Pk N4*

BOTTOM: *Roedde House Museum. | Roedde House Museum*

invited me to create anther a curated dinner, this time to commemorate the riot's 130th anniversary on February 24, 2017.

I wanted the meal to reflect the cultures of those who had done the attacking and those who were attacked, as well as the time and place of the event. So I conducted research in the city archives, where I found menus from the 1880s. Unfortunately, since most archivists until relatively recently were white, the collection reflects that influence and does not contain any Chinese restaurant menus from that time period. So, I approached Chinese elders about what they and their parents ate and which ingredients were available way back when, with the understanding that most of the Chinese back then came predominantly from villages in two particular counties in Guangdong province.

Chefs Wesley and Jacob were once again enlisted to cook, intrigued by my promise to share with them my archival menu findings. That Wesley is a descendent of a Chinese head tax payer and Jacob grew up in England and has a keen interest in local food history also contributed to their approach in developing a menu that paid homage to that time and place.

The historic Roedde House Museum was chosen as a strategic place to stage *The Unwelcome Dinner*. Built six years after the riots, this late-Victorian home is situated near Coal Harbour in the former forest that Chinese labourers were later on brought back to clear. The Roedde family were immigrants from Germany and had a Chinese houseboy named Hung. The chefs devised an elaborate meal with English, German, and Chinese influences, including steamed rockfish, siu choy, spaetzle, five-spice "pidgin" pie with indigenous sunchokes (a nod to Chinook Jargon, the trade language common along the West Coast in the nineteenth century), and petits fours accompanied by Hong Kong Café–style apple tarts. One course was dedicated to Hung, speculating

Canapés

Local oysters with champagne gelée
Olive tapenade with celery

Soup

Mushroom seafood broth with mo qua

Fish

Steamed red rockfish
Sichuan style potato citron vinaigrette

Pidgin Pie

Chinese 5-spice pigeon in pastry
roasted sunchokes

Roedde's upstairs pork loin, Hung's downstairs chop suey

Pork loin of pork with
spaetzle baby cabbages mustard sauce
Siu choy shredded pork chop suey

Dessert

Petit fours fruit jellies
sesame rice balls "Apple Tart"

Wines and Liqueurs

Old Fashioned Cocktail
whisky, bitters, simple syrup, cherry

Canadian Club rye whiskey

Tantalus Okanagan Riesling

Selbach Mosel Riesling

Coffee and Tea

Treasure Green Tea Centre A Special Party Blend
Lychee, Rose Black, and Jasmine Blossom Green

Neates Tomahawk coffee

Etc.

Shirley Temple
Grenadine, ginger ale

▲

The Unwelcome Dinner *menu (non-vegetarian option), 2017.* | *Henry Tsang*

on might have happened if he brought a slab of pork for Mrs. Roedde to cook, then was given the trimmings, which he then took to a friend's house to make fried rice with. I developed the period-appropriate drinks menu, with Old Fashioned for the Scottish and English merchants, Riesling (both German and British Columbian) for the Roedde family, and Chinese tea and coffee to accompany dessert.

Guest speakers were invited to address the impact of the riot and of race relations in the city, as well as what food might have been eaten by those involved in the riot. Hayne Wai of the Chinese Canadian Historical Society of BC spoke on Chinese Canadian history, the 1887 riot, and other unwelcoming acts against the Chinese. Kevin Huang of the Hua Foundation, an activist organization working with youth in community building and empowerment, addressed the historical restrictions against Chinese market gardeners from selling their produce and the current food security issues facing low-income seniors. Food critic Stephanie Yuen described how Chinese cuisine has evolved in Vancouver since incorporation and the recent culinary influences of Hong Kong and China. And Chefs Wesley and Jacob shared their family histories, as well as the stories they were telling through the dishes being served.

These two experiences of employing food as metaphor were exciting and heartening, creating unique aesthetic, conceptual, and sensorial experiences. But some factors left me unsatisfied. These projects had required a fixed place to hold the event and a fee to participate (and eat). Although the prices were kept to a minimum, I knew it was still more than what some folks could afford. And because the spaces were small, the tickets—a dozen for the *Orange County* dinner, two dozen for *The Unwelcome Dinner*—had sold out within a day. There was an exclusivity about these events that I was uncomfortable with, so when I had an opportunity to create an ephemeral public artwork as part of

48 — WHITE RIOT

WHERE YOU ARE STANDING — 49

Ten Different Things, a series of ten commissioned projects in public spaces curated by Kate Armstrong, I built on the foundation laid by *The Unwelcome Dinner* and moved it outside.

RIOT FOOD HERE addressed the 1907 anti-Asian Riots in the form of pop-up food offerings in four locations over four weekends in the summer of 2018. The food reflected the tastes of demographic groups of the time, specifically Chinese, Japanese, Punjabi, Indigenous, and white. The four sites were along the route taken by the Asiatic Exclusion League's demonstration and parade, starting at the Beatty Street Drill Hall across from the Cambie Street Grounds (Larwill Park), where the anti-Asian demonstration began with a parade led by the major of the BC Regiment, followed by multiple marching bands, a cavalcade of cars carrying the mayor of Vancouver and other luminaries, and thousands of supporters of the cause. The second location the following week was at the parade destination, the Old Market Hall (then City Hall), where the mob formed to attack the Chinese. The third stop was at the Dr. Sun Yat-Sen Classical Chinese Garden near the heart of Chinatown, and the final location was the Powell Street Grounds (Oppenheimer Park), near where the riots subsided over two days later.

The program began with a walking tour about the riots led by Michael Barnholden. It was during this event when the thought entered my mind: What if this tour was available as a self-guided experience? And what if it was interactive, with archival imagery to accompany the information and insight that Michael was providing—and site specific? What if it was a 360 video experience that blended the here, the now, and the past? And so I came up with the idea for what would become *360 Riot Walk*.

For RIOT FOOD HERE, food was the medium through which questions were posed: What would you have eaten just before you attacked the Chinese and Japanese? What would you have eaten just before the angry

▲
RIOT FOOD HERE *sign, 2018.* | *Photo: Henry Tsang*

◄
The Unwelcome Dinner *guests, 2017.* | *Photo: Cecilia Yuan Liu, courtesy of Centre A: Vancouver International Centre for Contemporary Asian Art*

white men came to attack you in your community? Or what would you have eaten as you watched the angry white settlers attack the Asian settlers on your land? What kind of food would have represented your people, your culture, your preferences, your biases?

In researching the five cuisines that people in the area might have been eating at the time, I returned to the municipal and provincial archives, but again, the holdings reflected a mainly white colonial perspective. So I went searching for oral histories, interviewing elderly people who had grown up here and those who are familiar with the ways of the elderly people, their traditions and habits. Eating was much simpler back then; most people ate the same things most of the time. Because Vancouver was a port city, the different communities were able to import specific foodstuffs that nourished them by giving comfort to their minds and bodies, which were physiologically similar but culturally distinct.

With my list of ingredients and potential dishes that reflected the relative socioeconomic differences between the different communities, I approached Michael's son, Chef Kris Barnholden, whose work I had been following for some time. He was intrigued about cooking for an art project and contributed his own flourishes in interpreting what people had eaten back then. The resulting menu was in itself an intercultural journey: candied salmon with pickled spruce tips (Indigenous, with salmon being the main protein staple); daal and chapatis (Punjabi, which the mill workers apparently ate a lot of, as it was cheap); pork and corn congee (Chinese, as congee is a poor person's meal, but with added meat protein and corn); roast beef with horseradish and Yorkshire pudding (very English, especially for Sunday dinner); and for dessert, mochi with red bean paste (Japanese, in reference to the many sweets shops along Powell Street).

▶
RIOT FOOD HERE *food*, 2019. |
Photo: Henry Tsang

At each location, a wooden sign with the words "RIOT FOOD HERE" roughly hand-painted onto it was erected next to a makeshift table made from scrap lumber, as if it had been hastily assembled from the wreckage of the aftermath of a battle, even though the tables were in reality carefully designed and constructed by local artist Stephan Wright. Stools and place settings were positioned around the table, and passersby were invited to sit, eat, and share what they knew about Vancouver and, in particular, the 1907 riots.

It was remarkable how different each experience was, or perhaps predictable if one were to hold to the adage or cliché that art is a mirror of the world around us. Each gathering at each location was shaped by the accidental participants who decided to stop on the street and take part. These conversations were opportunities for participants to share their lived experiences and their knowledge of the places they had lived (and sometimes their lack of it), which in turn exposed the level of engagement that inhabitants in different neighbourhoods of the city have with their local community.

The first location was downtown in front of the Beatty Street Drill Hall, near the underground SkyTrain station, where pedestrians were all clearly on their way somewhere. Some were locals, some tourists, most were middle class. These conversations were respectful and polite, congenial. The second location was in the heart of Skid Road, next to a busy bus stop, with street folks and drug dealers curious enough to join in by sitting or by standing back, observing. These interactions were much more lively and opinionated and demonstrated the participants' deeper understanding of local history and commitment to their community. Many talked openly about their experiences with racism, as well as challenges that their neighbourhoods were facing, including substance addiction, poverty, or basic survival in the Downtown Eastside.

▶

CLOCKWISE FROM TOP LEFT: *Henry Tsang at* RIOT FOOD HERE *Beatty Street Drill Hall location, 2018; Henry Tsang and Kris Barnholden at* RIOT FOOD HERE *former City Hall location, 2018; Henry Tsang at* RIOT FOOD HERE *Oppenheimer Park location, 2018; Henry Tsang at* RIOT FOOD HERE *Dr. Sun Yat-Sen Classical Chinese Garden location, 2018.* | *Photos: Emiko Morita*

Colourful characters would approach the table and offer commentary to whomever would listen to them, then wander off. The third location, in Chinatown, had a higher number of visitors from other places who were less informed about local history, resulting in my having to talk more, with less resultant conversation. The final location was in the relaxed environment of Oppenheimer Park, where participants displayed their awareness of the riots, of the many cultural communities that have lived there, and of the historical conditions of strained race relations. Over the course of the four weeks, stimulating dialogical experiences were shared over food that brought in people from various walks of life to reflect on the ongoing struggle, since colonial times, about who has the right to live and eat here.

The years following the launch of *360 Riot Walk* have been remarkable. The year 2020 ushered in the COVID-19 pandemic, and with it a dramatic rise in anti-Asian violence, fanned by anti-China sentiment. If there were ever any doubt about whether events elsewhere have an impact locally, this is yet more proof. Racism by association resulting in pan-Asian discrimination and targeting of vulnerable people, especially lower-income seniors and single women, became its own epidemic.

In the same year, protests erupted in the United States, Canada, and overseas following the deaths of George Floyd, Breonna Taylor, and too many other Black people at the hands of police. The historic efficacy of the Black Lives Matter movement and public awareness of systemic racism across many sectors of society, in particular the dominant culture, has created an environment in which inequality is more readily acknowledged and taking action against it is even encouraged. This did not exist in 2019 when the tour was created. The recent increases in

◀
RIOT FOOD HERE *participants at former City Hall location, 2018.* | *Photo: Emiko Morita*

anti-Asian, anti-Black, anti-Muslim, and anti-Indigenous violence are all part of the legacy of historical and current racism.

In 2021, the unhoused people squatting in a tent city at Oppenheimer Park, Stop 13 of the tour, were forcibly removed by the City, scattering them to other locations such as CRAB Park and elsewhere. This was but one of many instances of the ongoing political, existential, and sometimes violent struggle over the question of who has the right to live here that stretches back to the disruptions and dislocation of Indigenous Peoples in the nineteenth century. On February 14, 2022, Valentine's Day, during the fourteenth Annual Women's Memorial March in honour of Missing and Murdered Indigenous Women and Girls, a splinter group of demonstrators toppled the statue of "Gassy Jack" in Gastown, as seen in Stop 1. This was done in protest of saloon owner John "Gassy Jack" Deighton's marriage to a Squamish woman and, after her death, to her twelve-year-old niece, who later ran away.

In the short time since the original 360 photographs were taken for *360 Riot Walk*, there has been plenty of other visual evidence of changes to Vancouver's urban landscape. Real estate development continues its unrelenting march, spurred on by the city's zoning policies, which in combination with property taxes based on potential rather than actual use, results in the teardown of older buildings that cannot generate the income needed for newer higher-density rates. "Housing affordability" became an oxymoron in Vancouver in the early 2000s, contributing to the homelessness crisis exacerbated by the gentrification of the Downtown Eastside and the reduction of single-room occupancy (SRO) units and rooming houses. And in these neighbourhoods, the ongoing socioeconomic precarity, issues of mental illness, opioid addictions and resultant deaths, and the challenges of reconciliation have increased, if not accelerated.

◀
RIOT FOOD HERE *participants at Dr. Sun Yat-Sen Classical Chinese Garden, 2018.* | *Photo: Naiya Tsang*

Menu

SALMON AND WILD GREENS

DAAL AND CHAPATI

ROAST BEEF WITH HORSERADISH AND YORKSHIRE PUDDING

CONGEE WITH PORK

MOCHI

Schedule

ALL EVENTS 2 - 4PM
or until the food is gone

MONDAY MAY 21
Walking Tour with Michael Barnholden (meet at 2:00)
Beatty Street Drill Hall, 620 Beatty Street

SUNDAY MAY 27
Beatty Street Drill Hall, 620 Beatty Street

SUNDAY JUNE 3
Former City Hall, 425 Main Street

SUNDAY JUNE 10
Dr. Sun Yat-Sen Garden, 578 Carrall Street

SUNDAY JUNE 17
Oppenheimer Park, 400 Powell Street

▲
RIOT FOOD HERE *menu and schedule, 2018.* | *Henry Tsang*

Since the formative decades of Vancouver's founding, much has been gained from a human rights perspective, but much more work is needed to achieve equality and justice for all. My hope is that by raising awareness of the 1907 anti-Asian riots, *360 Riot Walk* can encourage dialogue and reflection on who has the right to live here. It is an opportunity to place oneself within the nexus of these many conditions and time frames, to stand within the continuum of temporality, and to reflect on one's position in this very particular place and time.

360 RIOT WALK SCRIPT

**MICHAEL BARNHOLDEN
AND HENRY TSANG**

◂

360 Riot Walk tour participants in Gastown, 2019. | *Photo: Henry Tsang*

Stop 1: Maple Tree Square, Gastown. | 360 Riot Walk

STOP 1:
MAPLE TREE SQUARE, GASTOWN

Where you are standing is the beginning of Vancouver: Maple Tree Square. This was also known as Luk'luk', which was a seasonal camp for the Indigenous Musqueam, Squamish, and Tsleil-Waututh Nations.

Ta newyap n síiyay̓. Chayap wa lhílhx̱i7lsh na7 tkwa Lek'lék'i úxwumixw. Tay̓ temíxw swa7 tl'a Xwemétskwiyamulh, Selílwitulh iy Skwx̱wú7meshulh. Na tiná7 tl'a tkwa Lek'lék'i n swá7am-cht ímen. An chet wenaxws ti temíxw, ti stakw, ti smanít iy i7x̱w ta S7ukw'ukw'íṅexw. Wenáxwstumiyap ti temíxw ímen. Wa Chayap yuu. Tiṁá tkwétsi n sníchim.

(Translation from Squamish: Hello, my friends. You are standing in the village of Lek'lék'i. This land is Musqueam, Tsleil-Waututh, and Squamish. Our ancestors are here in this village as well. We deeply respect this land, these waters, the mountains, and all the animals. We ask you to respect this land too. Walk gently.)

The Musqueam lived on the Fraser River to the south, at c̓əsnaʔəm and maləẏ. The Squamish lived at Sen̓áḵw at the mouth of False Creek, and X̱wáẏx̱way and Tayoosh at the head of Burrard Inlet. The Tsleil-Waututh lived farther up Canal de Sasamat, as the Spanish named Burrard Inlet and Indian Arm at what is now known as Belcarra. For thousands of years, they shared the territory in this area in seasonal camps, where the bounty was harvested to sustain life as they had done since time immemorial.

This place was also the north end of a portage route, where canoes could be carried from Burrard Inlet to False Creek. During high tides, that same canoe could be paddled along the shallow channel that connected the two bodies of salt water.

Then the Europeans began to arrive. First they came for animal furs. Then they took whales and oolichan, an oily smelt fish highly prized by the local peoples, for oil to lubricate their machines and to burn for heat and light. They cut down trees to send to Europe, where bigger and faster ships were built to carry more resources away. Then they came for gold, silver, and copper. They traded for some items, while others they simply took.

They brought Kanakas from Hawaii to work in the fur trade at Fort Langley. Some stayed and married Squamish women and lived at the Kanaka Rancherie near Coal Harbour, where they learned the language and raised Squamish children. The Europeans brought Chinese to clear

the land, work the mines, and build the railroad. Black men, Chinese men, and white American men came in great numbers to go up the river and prospect for gold.

They also brought their diseases such as smallpox, causing the collapse of the First Peoples. Shortly after 1862, there were only fifteen Tsleil-Waututh left.

Vancouver's first election took place in 1886. One of the candidates for mayor was Richard Alexander, the manager of the Hastings sawmill. He brought sixty Chinese and Indigenous workers to the polling station to vote for him. A riot by the whites broke out because Asians and Indigenous people were not allowed to vote.

Two months later, the Great Vancouver Fire burned down almost every wooden structure in the new city. The recently elected city council used this as an opportunity to pass bylaws that restricted anyone who was Chinese from rebuilding. Then the Knights of Labour organized a boycott of all Vancouver businesses that employed, sold food to, or in any way served Chinese residents. A black cross was painted in front of any store that did not participate in the boycott. Businesses were intimidated into firing Chinese and hiring whites as replacements. Funds were made available to any Chinese willing to leave the city. A company was formed to buy out Chinese businesses, and some Chinese workers were simply taken to the docks and put on the steamer to Victoria on Vancouver Island, "back to where they came from."

There were many public gatherings of white residents addressing what they considered to be the "problem" of Chinese presence. On February 24, 1887, during a packed meeting at City Hall, some three hundred angry white men raced to the camps of the Chinese labourers at Coal Harbour, who had been hired to clear the land of trees in what is now the West End. There, they attacked the Chinese workers, knocked down their tents, then burned all their bedding, clothing, and provisions.

For your next location, turn south and go two blocks to the northeast corner of Carrall and Hastings.

◀

Stop 1: Maple Tree Square, Gastown. | 360 Riot Walk

STOP 2:
CARRALL STREET AND EAST HASTINGS STREET

Stop 2: Carrall Street and East Hastings Street. | 360 Riot Walk

This corner of Carrall and Hastings was the centre of Vancouver's first entertainment district. There were several theatres here, and many bars.

Across the street to the west is Pioneer Place, the official name of what we now call Pigeon Park. It was constructed in 1932 when the rail line from Burrard Inlet to False Creek was rerouted.

At the southwest corner was the BC Electric Railway interurban streetcar depot, which operated from 1891 to 1958. At its peak, about ten thousand people rode the train twice a day between Vancouver and Chilliwack, with more travelling between Steveston and New Westminster.

The business interests of the dominant European immigrants forced communities of colour into the more undesirable and precarious areas of the city, forming ethnic ghettos.

This was common at the time. Anti-Asian and anti-Indigenous sentiments were rampant. Asiatic Exclusion Leagues were formed in all major cities along the West Coast. They wanted to restrict the immigration of so-called "Asiatics": Japanese, Chinese, Koreans, Filipinos, and South Asians (mainly Sikhs from the Punjab whom they inaccurately referred to as "Hindoos" [sic]).

For your next location, turn east and go one and a half blocks on the north side of Hastings, stopping at 139 East Hastings.

LEFT: *"The Collision: The Anti-Chinese Riot at Seattle,"* illustration in West Shore Magazine, *March 1886.* | *University of Washington Libraries, Special Collections, Seattle, SOC0014*

RIGHT: *Stop 2: Carrall Street and East Hastings Street.* | 360 Riot Walk

Stop 3: 139 East Hastings Street, just west of Balmoral Hotel. | *360 Riot Walk*

STOP 3:
139 EAST HASTINGS STREET, JUST WEST OF BALMORAL HOTEL

These two blocks of Hastings Street between Carrall and Main were some of the busiest commercial streets in the city. Most of the stores were operated by whites, but there were nine Chinese businesses as well.

Across the street to the left is where the 650-seat vaudeville-style Pantages Theatre was under construction at the time of the riots. Alexander Pantages began his career in the entertainment business in the Yukon in 1901, using money borrowed from the dancer Klondike Kate, known as "the flame of the Yukon." He soon owned a string of theatres up and down the Pacific Coast, from Hollywood to Vancouver.

HAVE WE A DUSKY PERIL?

HINDU HORDES INVADING THE STATE

PANTAGES THEATRE.
UNEQUALED VAUDEVILLE

PANTAGES THEATRE.
UNEQUALED VAUDEVILLE

PANTAGES

In 1907, there was an economic depression, with increasing unemployment. Over eight thousand Japanese immigrants arrived in the first ten months of that year, an unprecedented increase from previous years. The Grand Trunk Pacific Railway had lobbied Ottawa to let it import ten thousand Japanese workers to build its line in Northern British Columbia. Racial tensions flared.

British Columbia's Attorney General, William Bowser, proposed an immigration act that would significantly restrict Asians from entering the province. But it was not given royal assent by the Lieutenant-Governor, mainly because it violated international treaties with Japan.

In July, over 1,100 Japanese men from Hawaii arrived in Vancouver aboard the ss *Kumeric*. They came to fulfill labour supply contracts between the Nippon Supply Company and the Canadian Pacific Railway. They also came to escape the outbreak of bubonic plague on the Hawaiian Islands.

Then on September 5, some five hundred Punjabi sawmill workers in Bellingham, ninety kilometres (fifty-five miles) to the south in Washington state, were attacked by white labourers and marched out of town. Those who went north were allowed into Canada only because they were British subjects. Many arrived in Vancouver just in time to witness the riots here.

For your next location, continue east on Hastings until you reach Main. Cross Main, then Hastings. Go south half a block and stop at 438 Main.

Stop 4: Main Street, half a block south of Hastings Street. | 360 Riot Walk

STOP 4:
MAIN STREET, HALF A BLOCK SOUTH OF HASTINGS STREET

Across the street looking west, to the left of the Carnegie Community Centre, is where the Old Market Hall once stood. Between 1897 and 1929, City Hall was located on the second floor. The ground floor was a public market that also functioned as an auditorium for two thousand people.

In 1907, the Vancouver Trades and Labour Council, a conservative labour organization, founded its own chapter of the Asiatic Exclusion League. Four hundred men attended its first meeting on August 12. It was modelled on the Japanese and Korean Exclusion League in San Francisco and many such others throughout the West Coast. They advocated for a "white man's country" and the prohibition of Asian labour, to

be achieved through legislation and violence, if necessary. The mayor of Vancouver, Alexander Bethune, and several city councillors were founding members, along with many Christian leaders.

The Asiatic Exclusion League immediately organized its first event: a public demonstration on Saturday, September 7, the weekend after Labour Day, followed by a parade and speeches at City Hall.

A crowd gathered at 7:00 p.m. at the Cambie Street Grounds, now known as Larwill Park in downtown Vancouver. Led by Major E. Brown from the BC Regiment at the adjacent Beatty Street Drill Hall, a cavalcade including Mayor Bethune and his wife, followed by labour and church leaders, was accompanied by five thousand people, many waving white banners reading, "A White Canada for Us." They proceeded toward Hastings Street, then to City Hall.

By the time they reached the Old Market Hall, many more thousands had joined in. Estimates range from twenty-five thousand to thirty thousand, over a third of the population at the time. Only a small fraction of the crowd was able to enter City Hall to hear the speeches, so runners went back and forth to the crowd outside to relay what was being said. A resolution calling on the federal government to perpetually exclude Asians from Canada was enthusiastically passed by the newly formed organization. Guest speakers included clergymen, lawyers, politicians, and anti-Asian activists from New Zealand and the United States. A.E. Fowler from Seattle's Japanese and Korean Exclusion League came out onto the front steps to whip the crowd into a frenzy.

Then an angry mob formed, marching down Dupont Street (now Pender) toward Chinatown. Reports claim that the first window was broken by a boy who had picked up a brick from the construction site of the Pantages Theatre.

For your next location, continue south on Main. Cross Pender, then Main. Stop at the southwest corner.

◀

Stop 4: Main Street, half a block south of Hastings Street. | 360 Riot Walk

Stop 5: Westminster Avenue and Dupont Street (Main and Pender). |
360 Riot Walk

STOP 5:
WESTMINSTER AVENUE AND DUPONT STREET (MAIN AND PENDER)

In 1907, this corner was Westminster Avenue (now known as Main Street) and Dupont Street (which was changed to Pender just after the riots). This was the entrance to Chinatown, into which the mob swarmed. Local residents on the street were caught by surprise and ran into the nearest buildings for cover. The rioters identified which businesses were run by Chinese and smashed their windows and vandalized their buildings.

Across the street to the east, at 518 Main, is the location of the photography studio of Yucho Chow. He opened his first studio in 1906 at 68 West Hastings, then moved to various locations until, in 1930, he

settled here until his death in 1949. His two sons, Peter and Philip, then took over and continued operations a few doors down, at 512 Main, until 1986.

Boasting that his studio was "Open day and night, rain or shine," Yucho Chow photographed thousands of families, weddings, business people, and entertainers. He kept an array of props that could be used by his customers: a gold pocket watch, a necklace, books, and other items that would lend his subjects an air of prosperity and success.

The importance of Chow's work lies in his nonexclusionary photography practice. Many white photographers—in fact, many white businesses—would not serve non-whites. Chow, however, welcomed anyone from any background into his studio. He documented all of the marginalized communities who lived in the Strathcona area: Chinese, Japanese, Sikh, Black, Eastern European, and interracial families.

The Black residents of Vancouver were not concentrated in one location at the time of the riots. As their numbers were small, they were not considered the same kind of threat as the Asians. Later, many would live in and around Hogan's Alley, three blocks south of this corner.

For your next location, go west on Pender for two blocks. Stop at the southeast corner of Pender and Carrall.

Stop 6: West Pender Street and Carrall Street. | 360 Riot Walk

STOP 6:
WEST PENDER STREET AND CARRALL STREET

Diagonally across the street on the northwest corner is the Chee Kung Tong Chinese Freemasons Building. During high tides, the water in False Creek would come all the way up to Dupont Street (now Pender). The Chinese revolutionary leader Dr. Sun Yat-Sen stayed in one of the second-floor bedrooms on one of his fundraising trips to Vancouver. The main floor housed the Pekin Chop Suey House. In the years following the riot, laws were passed forbidding white women to be employed in restaurants owned by Chinese.

Looking to the north and to your right, the Wing Sang Building at 51 East Pender was built in 1889 for influential businessman Yip Sang.

TOP & BOTTOM: *Stop 6: West Pender Street and Carrall Street.* | 360 Riot Walk

Boarded-up buildings in Chinatown after 1907 race riots. | *Photo: Philip Timms. Vancouver Public Library, 939*

Like many of the Chinese who came to Vancouver, Yip Sang came from Taishan county in Guangdong province. At age nineteen, he sailed to California, where he worked as a dishwasher and cook. He came north to look for gold in the Cariboo but was unsuccessful and eventually settled in Vancouver, where he first sold coal door to door. Because he was educated and spoke English well, he became a labour contractor for the Canadian Pacific Railway, at one point overseeing seven thousand workers.

When the mob entered Chinatown in 1907, the Chinese people there were initially taken by surprise. But then, they began to organize and to fight back. Although there were no documented deaths due to the riots, there were close calls. The *Vancouver Daily Province* reported that in Canton Alley, a Black woman jumped into the fray and managed to get a white rioter by the name of McGregor into a door, where she protected him from his assailants until the arrival of the police.

By ten o'clock, the police force had called in all of their off-duty officers, totalling about two dozen. Badly outnumbered, they were unable to have any effect, and their own safety was in doubt. The fire brigade was also called in to help.

Arrests were few, in part because the crowd would rescue anyone captured. One report set the number of arrests at twenty-four, noting that the procedure was a joke. Another commented that among the arrested were "laborers, bookkeepers, loggers, men who don't have to work ..." and "those with few political friends." Only five rioters were eventually found guilty and given jail terms of one to six months.

The local English language press blamed American labour leaders for inciting the riot. Those who travelled to speak as special guests included A.E. Fowler, mentioned earlier; Frank Cotterill, president of the Federation of Labor of the State of Washington; and George P. Listman, a prominent labour leader from Seattle. However, the Chinese language press placed the blame squarely on local white unions, most of which were involved in anti-Asian activism and provocation.

One notable exception was the Bows and Arrows, a multiracial lumber handlers industrial trade union. One of the founding members was John St. John, a Black man from Barbados. The majority were Indigenous workers from the Capilano Indian Reserve. They decided to affiliate with the Industrial Workers of the World, known as "Wobblies," one of the few anti-capitalist and anti-racist unions, unlike those who supported the Asiatic Exclusion League.

For your next location, continue west on Pender by crossing Carrall. Then turn left at Shanghai Alley. Go to the commemorative bell near the end of the block.

STOP 7:
SHANGHAI ALLEY
(CHINATOWN HERITAGE ALLEY)

Stop 7: Shanghai Alley (Chinatown Heritage Alley). | 360 Riot Walk

This is Shanghai Alley, which, with the adjacent Canton Alley, was the economic and cultural centre of the early Chinese community. Chinatown was home to several thousand residents, mostly adult men. Looking north on this street to your right is the former location of the Sing Kew Chinese Theatre, where Cantonese opera was performed and where Dr. Sun Yat-Sen spoke to packed houses about political revolution in China.

The *Vancouver Daily World* reported that "Nothing could be more systematic than the determination with which the mob picked out Japanese and Chinese windows and spared those right adjoining if they

were those of whites. On Columbia Avenue, for example, all the Chinese windows were broken and those of two white real estate brokers were left whole."

On Monday morning, the *Daily Province* reported, "The Chinese armed themselves as soon as the gun stores opened. Hundreds of revolvers and thousands of rounds of ammunition were sold before the police stepped in and requested that no further sale be made to Asians."

To the south was a jetty that ran out into False Creek and the sawmill complex where many Chinese labourers worked.

Employment options were limited, as most professions were closed to Asians, and many shops and factories were intimidated into refusing to employ them by the white unions that controlled hiring.

The City of Vancouver, along with the provincial and federal governments, carried out what can only be described as institutional racism against Asians, Blacks, and Indigenous people. This included disenfranchisement, taking away their right to vote; keeping them from practising professions; and restricting them from living in other parts of the city.

The Chinese Immigration Act of 1885 imposed a head tax of fifty dollars on any Chinese person entering Canada. This rose to a hundred dollars in 1900, then to five hundred dollars three years later. No other group in Canadian history has ever been forced to pay a tax based solely on their country of origin. In 1923, the exclusionary Chinese Immigration Act banned almost all Chinese people from entering Canada and was not repealed until 1947.

For your next location, go back to Pender, turn right, and go to the northwest corner of Pender and Columbia.

▶

Shanghai Alley after Chinatown riots, 1907. | *Photo: Philip Timms. University of British Columbia Library, Chung Collection, Vancouver,* CC-PH-10626

華益棧

WAH YICK JUNG & CO.
595 SHANGHAI ST.

84 — WHITE RIOT

▲
Stop 7: Shanghai Alley (Chinatown Heritage Alley). | 360 Riot Walk

Stop 8: East Pender Street and Columbia Street, northwest corner. | *360 Riot Walk*

STOP 8:
EAST PENDER STREET AND COLUMBIA STREET, NORTHWEST CORNER

One block north on the corner of Columbia and Hastings is the oldest and only wood building remaining on that stretch of East Hastings, built in 1893. In 1907, after the riots, the business owner, Fongoun, asked for $350 in damages, which included $144 for the broken window and wages for his staff during the two weeks his shop was closed. Fongoun was the city's top tailor, and most of his clientele was white.

However, most Chinese workers at the time were effectively indentured servants, because they were not direct employees, but rather, contracted to "labour sharks" such as Yip Sang who paid their head tax and travel expenses. Their wages, which were much lower than of white

86 — WHITE RIOT

workers, were paid to the "shark," who withheld their share and any monies owed until the debt was paid. As the head tax increased over the years, the length of time spent earning one's way to freedom grew longer and longer. Until then, the worker was at the mercy of the labour contractor and the employer.

Yip Sang helped establish the Chinese Benevolent Association at 104–108 East Pender, which also housed a Chinese school and a hospital upstairs. He was also a social and political activist and was part of the Chinese Empire Reform Association, which advocated for modernization of China through progressive reform, as opposed to revolution.

Yip owned an opium factory at 34 Market Alley. After the riot, he requested compensation for opium that was destroyed and for the many revolvers that he purchased for protection after the riot. Both requests were denied.

When Vancouver's city council passed a bylaw prohibiting Chinese from owning land, Yip found a loophole. Companies owned by Chinese were not included in this restriction, so he used his import-export firm, the Wing Sang Company, to acquire the land.

For your next location, go north on Columbia for three blocks. Cross Powell, turn right, and stop across from 122 Powell.

◄

Stop 8: East Pender Street and Columbia Street, northwest corner. |
360 Riot Walk

Stop 9: Across from 122 Powell Street. | 360 Riot Walk

STOP 9:
ACROSS FROM 122 POWELL STREET

On late Sunday afternoon, the rioters regrouped just to the east on Westminster (now Main Street). That was the entry to what the Japanese called *Nihonmachi*, which literally means "Japantown," and Paueru Gai, the Powell Street area.

The Japanese had almost a full day's warning to prepare for the inevitable attack, stockpiling bricks and rocks to throw at the rioters and arming themselves with guns and knives.

The *Daily Province* later reported: "The police on the scene were utterly unable to cope with the mass of struggling, cursing, shouting rioters who surged back and forth. Armed with sticks, clubs, iron bars,

Damaged 124 Powell Street building after the 1907 riots. | *University of British Columbia Library, Japanese Canadian Photograph Collection, Vancouver, JCPC-36-018*

revolvers, knives, and broken glass bottles, the enraged Japanese poured forth into the streets as soon as the limit of their patience had been reached."

The first Japanese arrived in Vancouver in 1877, where they worked in fishing, then in lumber mills. Initially, the Japanese government discouraged its citizens from leaving Japan. Men were needed for the Imperial War effort. These regulations were eased in 1889 due to food shortages and lack of opportunity. The Japanese government later opened a consulate in Vancouver.

The community's Asahi baseball team became a symbol of their struggle for equality and respect, applying the principles of work ethic based on terms from Japan's Meiji era, such as *isshokenmei*, or hard work, *gambari*, or perseverance, and *gaman*, self-restraint. Fans on both sides of the field began cheering the team's efforts, and English media praised their skilful play but still referred to them as "Japs" and "Nips," never acknowledging them as Canadians.

For your next location, continue east on Powell, stopping at 245 Powell.

▶

Stop 9: 122 Powell Street. |
360 Riot Walk

360 RIOT WALK SCRIPT — 91

STOP 10:
245 POWELL STREET

Stop 10: 245 Powell Street. | 360 Riot Walk

You have just passed the intersection of Westminster (now Main) and Powell. This was where many of the commercial buildings were clustered. Residences were located along Alexander and Cordova Streets. The first property bought by Japanese immigrants around 1898 was 230 Powell.

The Japanese community was in a slightly better position than the Chinese community in that Japan was an Imperial ally of the British, who set Canada's foreign policy. Japan was perceived as a rising power, having in 1905 just beaten Russia in a war, whereas China was considered weak and politically unstable.

However, like the Chinese, Japanese were barred from entering professions and from many jobs. They were barred from living in many areas of the city. Public places such as movie theatres and swimming pools were segregated, and some restaurants would not serve anyone who was Asian, Black, or Indigenous.

The Japanese-owned dry goods store on the southeast corner of Westminster and Powell was the first target of the thousand-strong mob, inflicting $2,400 in damages to the building and to merchandise with a steady barrage of stones and bricks.

The Japanese consul, M. Kishiro Morikawa, was on hand to request that Mayor Bethune order the police to protect the Japanese community. But the police were badly outnumbered. Hand-to-hand combat was taking place on the streets with clubs, knives, and guns. From the roofs of buildings, rocks, bricks, bottles, and blocks of wood were thrown at the rioters, who made it as far as the Powell Street Grounds (now Oppenheimer Park). The mob did not expect such resistance, nor the escalating number of casualties. After a number of pitched battles, the rioters began to disperse.

For your next location, continue east on Powell and cross over to the south side, stopping at 374 Powell.

230 Powell Street, boarding house, 1907. | Library and Archives Canada, Ottawa, PA-067274

94 — WHITE RIOT

▲
Stop 10: 245 Powell Street. |
360 Riot Walk

▶
264 Powell Street, 1907. |
Library and Archives Canada,
Ottawa, PA-067273

360 RIOT WALK SCRIPT — 95

Stop 11: 374 Powell Street.
360 Riot Walk

STOP 11:
374 POWELL STREET

At the east end of the block, at Dunlevy, sits the Tamura Building, built in 1912 by Shinkichi Tamura. He arrived in Vancouver in 1889 and founded the Tamura Trading Company, which exported lumber and wheat to Japan, and established the Japan-Canada Trust Savings Company in 1907. Tamura played a significant role in developing trade between Canada and Japan.

The Tamura Building was also known as the New World Hotel, one of the most substantial rooming houses in the neighbourhood. It was later owned by the Takahashi family, and then by the Sasaki family, who also owned one of the biggest bathhouses, the Matsuno-yu at 318 Powell.

360 RIOT WALK SCRIPT — 97

They were also involved in the Fuji Chop Suey House at 314 Powell, which served Chinese-style Japanese cuisine. It was one of the few restaurants where Japanese Canadian families could be served. Most other local restaurants were for men only. The second floor was rented out for weddings. Ironically, in 1942, this hall was used by the federal government to plan the uprooting and internment of the Japanese Canadian community and the dispossession of their properties.

In December 1941, the Imperial Japanese Navy attacked Pearl Harbor. The Canadian government subsequently invoked the War Measures Act. Some 22,000 Japanese Canadians were labelled "enemy aliens," uprooted from their homes, and sent to labour and internment sites in the BC Interior, Alberta, Manitoba, and Ontario. All personal property, such as fishing boats, farms, businesses, and homes, were confiscated and sold without owners' consent to pay for the costs of the internment. It was not until 1949, four years after the war was over, that these Japanese were allowed to return to the West Coast, but by then, many had been forced by the Government to settle east of the Rockies.

In 1988, after four decades, the Canadian Government finally delivered an apology, along with a compensation package.

The forced removal of the Japanese community from what had been a thriving Nihonmachi created a vacuum in the neighbourhood. The City rezoned the Powell Street area for industrial use, thereby discouraging the establishment of homes and businesses in what was perceived as a "slum." All this has contributed to the building decay, high vacancy rate, and socioeconomic disparity prevalent in the area today.

For your next location, continue east on Powell to Dunlevy, then turn left for one block until you reach Alexander. Turn right and stop on the south side near the middle of the block.

STOP 12:
400 BLOCK OF ALEXANDER STREET, JAPANESE LANGUAGE SCHOOL

Alexander Street was originally paved with wooden blocks, as trees were so abundant in Vancouver. It was named after Richard Alexander, the manager of the Hastings Mill who unsuccessfully attempted to bring his Chinese and Indigenous workers to vote for him in Vancouver's first election. Some of these wood pavers, over a hundred years old, can still be found in this area and have been preserved with creosote to increase the longevity of the road surface. The 1890 City Engineer's call for tender for the production and installation of these pavers explicitly stated that "no Chinese" were to be hired to perform any work involved.

Stop 12: 400 block of Alexander Street, Japanese Language School. | 360 Riot Walk

This area was once a seasonal campsite for Indigenous peoples called K̲'emk̲'emeláy̓, meaning "big leaf maple trees." In 1867, Captain Edward Stamp began producing lumber there at Stamp's Mill, which later became Hastings Mill.

Many of the longshoremen who worked on the docks were Indigenous men. Some lived in Stanley Park, including William Nahanee, the son of one of the Hudson Bay Kanakas who came from Hawaii. Workers used Chinook Jargon, a trade language, so they could speak freely among themselves without fear of reprisal for union organizing at work.

Across the street at 439 Alexander was the Vancouver Kyoritsu Nihon Kokumin Gakko, the Japanese language school. On early Monday morning, rioters tried unsuccessfully to set it on fire. This was the last known attack during Vancouver's 1907 anti-Asian riot.

The school had just recently opened their wooden building on January 12, 1906. It operated as a full-time school following Japan's education curriculum. General subjects were dropped in 1919 in favour of teaching Japanese Canadians both English and Japanese. In 1928, it was replaced by the current building at 475 Alexander on your right.

Just prior to the internment of Japanese Canadians in 1942, the school was forced to close. It was then occupied by the Canadian Armed Forces until 1947, when it was rented to the Army & Navy department store. The school was temporarily housed at the Vancouver Buddhist Temple and didn't reopen until 1952. Today it is a designated heritage building and an active and integral part of Vancouver's Japanese Canadian community.

For your next location, continue east on Alexander until Jackson, then turn right for one block until Powell. Cross Powell, then turn right and stop on the south side near the middle of the block.

Stop 12: 400 block of Alexander Street, Japanese Language School. | 360 Riot Walk

Stop 13: Powell Street Grounds (Oppenheimer Park). | 360 Riot Walk

STOP 13:
POWELL STREET GROUNDS (OPPENHEIMER PARK)

To the south is Oppenheimer Park, which opened in 1898 as the Powell Street Grounds, or Paueru Groundo in Japanese. It was a sports field, home to the neighbourhood's legendary baseball team, the Asahi. Indigenous people who felt unwelcome in Stanley Park after its founding in 1887 made this park their home.

In 1936, the Powell Street Grounds were designated by the city as the only place where public gatherings and demonstrations were allowed. Over the years, many large crowds gathered here to fight unemployment, poverty, and racism. During the Great Depression, a thousand

unhoused people were encamped in the blocks surrounding the park, foreshadowing the housing crisis Vancouver is facing today.

By Monday morning, September 9, the riots had died down, in part due to heavy rains. The Chinese Benevolent Association and clan associations organized a general strike that continued until Wednesday morning, shutting down many parts of Vancouver, including the sawmills and a third of the restaurants. The Japanese went to work Monday, but left in the afternoon to attend a public meeting at the Powell Street Grounds to discuss their demands for reparation from the city. Mayor Bethune came to address the crowd's concerns—ironic, given that he was one of the Asiatic Exclusion League's co-founders.

The Japanese and Chinese communities petitioned the government to pay for their damages. Businesses in Chinatown were closed for up to six days. The Chinese Benevolent Association offered the following assistance: "If any of you go back to your original workplaces and your employers are not willing to hire you and hire others instead, please report to the Chinese Benevolent Association and we will negotiate for you." They also announced, "Any Chinese people who have been beaten by westerners, please report to the Chinese Benevolent Association and we will negotiate with them."

Ottawa sent out the federal deputy minister of labour, William Lyon Mackenzie King, to conduct a Royal Commission inquiry. Pressure applied to England by Japan resulted in a swift response, with over $9,000 in settlement for damages in Nihonmachi. Compensation for the Chinese was slower, as they lacked the political support of an up-and-coming nation, but eventually totalled almost $27,000.

Interestingly, Mackenzie King's investigation revealed that some of the Chinese claims were for businesses related to opium, eventually leading to the creation of Canada's first anti-drug law.

441 Powell Street, 1907. | Library and Archives Canada, Ottawa, PA-066891

431 Powell Street, 1907. | Library and Archives Canada, Ottawa, PA-066890

S. Aoki
#431
S. Aoki
S. Aoki
House

Stop 13: Powell Street Grounds (Oppenheimer Park). | 360 Riot Walk

In 1909, Harvard University granted Mackenzie King a PhD for his dissertation on "Oriental Immigration to Canada." In it, he argued against the immigration of Asians, saying, "That Canada should desire to restrict immigration from the Orient is regarded as natural, that Canada should remain a white man's country is believed to be not only desirable for economic and social reasons but highly necessary on political and national grounds." Later, when Mackenzie King was prime minister during the Second World War, it was he who ordered Japanese Canadians to be interned.

In the period following the 1907 riots, Japan and Canada reached a Gentlemen's Agreement to reduce Japanese immigration to four hundred males a year. In 1928, that number was further reduced to 150.

In 1908, South Asians desiring to enter Canada were targeted through the Continuous Journey Regulation, which was tested in 1914 by the attempted landing of the ss *Komagata Maru*, which carried passengers from India who had stopped in Yokohama.

The Chinese head tax remained at five hundred dollars, but in 1923, the exclusionary Chinese Immigration Act came into effect until it was repealed in 1947, mainly as a result of Canada's signing the United Nations Universal Declaration of Human Rights after World War II.

The long history of legislated and social discrimination in Vancouver, British Columbia, and Canada can still be seen in the remaining landmarks of the communities that were the target of the 1907 anti-Asian riots.

106 — WHITE RIOT

360 Riot Walk *participants*,
2019. | *Photo: Henry Tsang*

Producer and Director: Henry Tsang

Writers: Michael Barnholden and Henry Tsang

Technical Director: Sean Arden

Visual Production and UX Design: Arian Jacobs, Adiba Muzaffar, and Evan Craig

Graphics: Hanif Janmohamed and Alex Hass

Translation and Voice: Catherine Chan (Cantonese), Yurie Hoyoyon (Japanese), Masha Kaur (Punjabi), Michael Barnholden (English), and Salia Joseph (Squamish)

Script Advisors: Grace Eiko Thomson, Hayne Wai, Emiko Morita, and Charlene George

Voice-Over Advisors: Debbie Cheung, Tadafumi Tamura, Taran Dhillon

Website and Public Relations: Agentic Digital Media, Liddleworks Indie Media, and Debbie Cheung

360 Riot Walk was created by Henry Tsang in collaboration with the Dr. Sun Yat-Sen Classical Chinese Garden and the Basically Good Media Lab at Emily Carr University of Art + Design. Community partners include the Powell Street Festival, the Japanese Language School and Japanese Hall, the Chinese Canadian Historical Society, the Carnegie Community Centre, and Project 1907.

Archival photographs are courtesy of Vancouver Public Library Special Collections; City of Vancouver Archives; Simon Fraser University Library; University of British Columbia Library Chung Collection; Nikkei National Museum & Cultural Centre; BC Archives; Library and Archives Canada; University of California, Berkeley, Ethnic Studies Library; Washington State Historical Society; Museum of Chinese in America; Sonoma County Library Photograph Collection; Western Washington University; Center for Pacific Northwest Studies, Museum of History and Industry; US National Archives; National Taiwan University Main Library; and Yucho Chow Community Archive.

The project was supported and developed by Creative BC, the British Columbia Arts Council, the City of Vancouver's Neighbourhood Matching Fund, and a SSHRC Explore Grant through Emily Carr University of Art + Design.

PACIFIC CHIVALRY.
Encouragement to Chinese Immigration.

Cartoon about anti-Chinese sentiment by Thomas Nast in Harper's Weekly, *August 7, 1869.* | Sonoma County Library, Santa Rosa, 039381

Uprooting the Racism in Our Ranks: Reflections from a Labour Perspective

STEPHANIE FUNG, ANNA LIU, KARINE NG 吴珏颖, AND CHRIS RAMSAROOP

As self-identified and visibly presenting Asian Canadians, each of us can recall times growing up when we endured racial taunts, harassment, and, in some instances, overt racial violence. Whether it was a seemingly benign children's rhyme or the proverbial "Go back to where you come from," our lives have been and continue to be etched with the idea that we are perpetually foreign. As we grew older, we saw that the overt racism we faced went beyond the surface. We came head-to-head with multiple layers of systemic and institutional racism that reinforced the idea that we did not belong. At our dinner tables, our parents whispered anger and resentment for being told their English was not good enough to be hired, or for being denied promotions or subjected to racial taunts in the workplace. Worse still, our parents who became sick or injured saw their lives spiral further into poverty. We saw first-hand how the so-called "Canadian dream" was, in fact, a series of nightmares for our communities.

RACISM AND THE PANDEMIC

Spring of 2020 saw the beginning of lockdowns in Canada due to the COVID-19 pandemic. While the economy ground to a halt and streets were emptied of activity, anti-Asian racism was bubbling up and rearing its ugly head.

Not much has changed since our childhoods—in fact, it seems to have become worse. Recently, Statistics Canada released data on police-reported hate crimes in the country. The findings show that "Between 2019 and 2020, the number of police-reported crimes motivated by hatred of a race or ethnicity increased 80%."[1] Additionally, crowdsourced data collected from over 43,000 Canadians revealed that, since the advent of the COVID-19 pandemic, 30 per cent of Chinese participants, 27 per cent of Korean participants, and 19 per cent of Southeast Asian participants felt there was an increase in the frequency of harassment or attacks based on race, ethnicity, or skin colour as a result of COVID-19.[2]

The surge in anti-Asian racism continued upward in 2021, with a 47 per cent increase in racist incidents. In particular, incidents involving South Asian and Southeast Asian people increased dramatically, by 318 per cent and 121 per cent, respectively. Women were involved in two-thirds of all cases, with nearly 75 per cent of reported incidents involving male and white offenders/perpetrators.[3]

As a consequence, racialized people considered their neighbourhoods to be less safe during the pandemic. Black, Indigenous, and other

[1] Jing Hui Wang and Greg Moreau, *Police-Reported Hate Crime in Canada, 2020,* Statistics Canada, March 17, 2022, https://www150.statcan.gc.ca/n1/pub/85-002-x/2022001/article/00005-eng.htm.
[2] Loanna Heidinger and Adam Cotter, "Perceptions of Personal Safety Among Population Groups Designated as Visible Minorities in Canada During the COVID-19 Pandemic," *StatCan COVID-19: Data to Insights for a Better Canada,* Statistics Canada, July 8, 2020, https://www150.statcan.gc.ca/n1/en/catalogue/45280001202000100046.
[3] *Another Year: Anti-Asian Racism Across Canada Two Years into the COVID-19 Pandemic,* Chinese Canadian National Council Toronto Chapter and Project 1907, March 2022, https://ccncsj.ca/wp-content/uploads/2022/03/Anti-Asian-Racism-Across-Canada-Two-Years-Into-The-Pandemic_March-2022.pdf.

racialized people also experienced lower levels of confidence in the police and higher levels of discrimination.[4]

Hate crimes only scratch the surface of the multiple forms that racism can take. General statements like "We're all in this together" were inconsistent with our experiences when the exact opposite occurred, when 28 per cent of Indigenous households and 31 per cent of other racialized households experienced economic insecurity, compared to 16 per cent of white households.[5] Racialized workers were more concentrated in industries that were most likely to suffer job losses from the pandemic and were more concentrated in front-line occupations at high risk of infection.[6] As such, the pandemic merely illuminated and further exacerbated existing societal and systemic discrimination faced by racialized communities—especially racialized women and gender diverse and nonbinary people.

A COMMUNITY ACTIVATED: THE ASIAN CANADIAN LABOUR ALLIANCE (ACLA)

ACLA is a grassroots organization founded in the year 2000, currently with active chapters in Ontario and British Columbia. The BC chapter had been dormant for several years, but was reinvigorated by the escalation of anti-Asian racism during the pandemic. A handful of labour activists and organizers of Asian heritage, including one founding member, began to seek each other out for support. In the fall of 2020, ACLA BC relaunched its chapter in time to mark the twentieth anniversary.

"The First Blow at the Chinese Question," illustration by George Frederick Keller in the San Francisco Illustrated Wasp, *December 5, 1877.*

4 Wang and Moreau, *Police-Reported Hate Crime.*
5 Angele Alook, Sheila Block, and Grace-Edward Galabuzi, *A Disproportionate Burden: COVID-19 Labour Market Impacts on Indigenous and Racialized Workers in Canada,* Canadian Centre for Policy Alternatives, December 2021, https://policyalternatives.ca/sites/default/files/uploads/publications/National%20Office/2021/12/A_Disproportionate_Burden_FINAL.pdf.
6 Alook, Block, and Galabuzi, *A Disproportionate Burden.*

PER CAPITA

CANADA
▲ Has more reported
▲ incidents than the
▲ United States

BY 100%*

*REFERENCE DATA: STOP AAPI HATE REPORTS (2020-2021), CANADA CENSUS DATA (2019), US CENSUS DATA (2019)

TYPE OF DISCRIMINATION

Verbal Harassment

is included in **67%** of all reports

Assault makes up **1 IN 4** incidents

▲ ▶
Community-collected data as of June 2021. | Project 1907

After the massacre of six Asian women in Atlanta in March 2021, ACLA worked with community partners to organize solidarity rallies attended by thousands in Toronto and Vancouver to send a strong message against racism and white supremacy. Because of public health orders restricting in-person gatherings during COVID, ACLA organized a series of online events to counter racist ideology as well as to break the isolation and anxiety that many people felt. Those who attended our events spoke freely of the fear they faced being Asian during the pandemic.

ACLA's organizing was also premised on building solidarity with other communities in struggle. We wanted to disrupt the model minority myth by examining anti-Asian racism in the context of anti-Black racism and the struggles of Indigenous communities. We are conscious that in times of crisis, it is easy to look internally and turn toward the same systems of oppression. The violence inflicted against us cannot be resolved by targeting and criminalizing other racialized communities. Our efforts must not be based on competition among one another; instead, we must challenge existing power frameworks that divide working-class communities. Our organizing is premised on dismantling systems of oppression rather than empowering them.

As many mainstream commentators attempt to historicize current forms of injustice, we want to connect them to the multiple deep-seated forms of racism that have particularly impacted Asian Canadians, who are the scapegoats of this pandemic and continue to be seen as the perpetual foreign other. From its inception, the Canadian settler state has been built on violence against Indigenous, Black, and other racialized communities. The question arises: how do we counter the existing mainstream narrative of Canada to rupture the myth and under-telling of the real history of violence and exclusion that has left out many of our voices?

WOMEN continue to be disproportionately impacted

reporting 2 OUT OF 3 incidents

East Asian 72% · SE Asian 16% · Mixed Race 5%

BRITISH COLUMBIA continues to have the most reported incidents per capita of any North American province, state, or territory*

(Per 100,000 capita: British Columbia ~9, California ~7, New York ~5, Ontario ~4.5, Washington ~4, Alberta ~2.5)

*REFERENCE DATA: STOP AAPI HATE REPORTS (2020–2021), CANADA CENSUS DATA (2019), US CENSUS DATA (2019)

WHOSE HISTORIES?

As marginalized settlers, knowing our own histories is necessary to navigating the journey toward justice and liberation. History is often presented to us as an official and immutable account—one that is rarely written by our own ancestors. That history will not give us power. Knowing our own truth is powerful in that it grounds us historically and orients us in the right direction to further the struggle, while honouring and building upon past endeavours.[7]

The history of Canada's labour movement is riddled with the exclusion of racial minorities. Those who fought to obtain positions within labour struggled not only for anti-racism initiatives, but for improvements for all workers. A prime example is the case of South Asian activists in British Columbia during the early to mid-twentieth century who were connected to the Ghadar Movement.[8] Despite facing discrimination and barriers to participating in the labour movement, their alliance with the BC left was enriching, adding an international outlook that was also anti-imperial and anti-capitalist. Combined with strong political organizing and an ethos of community care, they successfully mobilized and contributed greatly to the improvement of sawmill and farm workers. Many of the latter group were women. It can be argued that a living legacy has since opened the door for other marginalized settlers to participate in BC's labour movement—one that must now confront racism as part of its mandate.

[7] For further reading about the history of anti-racism struggles in British Columbia, see *Challenging Racist "British Columbia": 150 Years and Counting* (2021) by the University of Victoria and the Canadian Centre for Policy Alternatives, https://challengeracistbc.ca.

[8] Anushay Malik, "South Asian Canadians and the Labour Movement in British Columbia," in *A Social History of South Asians in British Columbia*, eds. Satwinder Kaur Bains and Balbir Gurm (Abbotsford: University of the Fraser Valley, 2022).

BEYOND THE REPRESENTATION RAINBOW AND EQUITY, DIVERSITY, AND INCLUSION (EDI)

These days, in the wake of renewed fervour in the Black Lives Matter movement and the resurgence of Indigenous sovereignty, Equity, Diversity, and Inclusion (EDI) is growing by leaps and bounds. While training, education, and institutional change are important to improving equity, there are many pitfalls that undercut their efficacy.

Authentic diversity requires those in positions of power to not only reflect diverse characteristics on a superficial level, but to actually represent marginalized communities by being in community and relationship with them. Meaningful equity demands that the leadership reflect its base, whether it be the membership, the workforce, or society at large. True inclusion welcomes marginalized folks to show up as their full selves, with the ability to express their cultural and spiritual practices. Real justice means that those in power also espouse and *enact* anti-oppressive beliefs, not just offer token gestures while upholding white supremacy values and culture.

Liberation for any and all settlers on largely stolen and unsurrendered lands will always be premised on the liberation of Indigenous Peoples. Even though our liberation is bound together, it would be disingenuous to elide or make light of the differences, nuanced or stark, between and within Indigenous nations, Black peoples, and other settlers of colour.[9]

Honest EDI work is fundamentally political. It behooves us to engage collectively in political processes in order to redistribute power and resources. Evaluating the efficacy of EDI work can be simple: Did it result in actual policy changes? Did it allow more racialized people to show up in their full identities? If not, how broadly and deeply engaged are those

9 Shree Paradkar, "Why I'm Saying Bye-Bye to 'BIPOC' This Year," *Toronto Star*, December 11, 2021.

who stand to benefit from such changes? If the engagement increased and sustained collective agency, as well as transparency, accountability, and participation in institutional processes, then EDI work will have achieved something worthwhile.

Otherwise, grassroots members who defer to experts (i.e., professional consultants) to do the work will never see it done, for this work is almost always paid for by institutions, whose impulse is to conserve the neoliberal interest to keep individuals isolated with very limited power and agency to effect systemic change. Even long-established, systemically entrenched EDI tools like employment equity plans fail when they are implemented as an end instead of as a tool. These initiatives and strategies alone do not make a workplace anti-racist.

ROLE OF UNIONS, THE FREEDOM CONVOY, AND EXTREMISM

From a labour perspective, unions play a crucial role in educating the rank and file to create a more progressive culture. After all, one can experience discrimination from one's boss as much as from one's co-workers. Unions can also bargain for anti-racism to be codified in collective agreements and translated into policies and procedures that, in turn, can have real impacts in practice. Advocacy (e.g., lobbying at the governmental level), mobilization (e.g., campaigning in conjunction with labour partners), and organizing (e.g., building and maintaining relationships between the rank and file) are tools to help effect social and political change.

One area we want to focus on is the rise of right-wing extremism in the Canadian labour movement. The Freedom Convoy[10] confirmed suspicions many of us had about members of our own house of labour. Leaked financial records revealed many elected officials, staff, and rank-and-file members as contributors to the convoy. Public social media posts also illustrated the xenophobic and racist beliefs held by some union members with power. However, we cannot simply look at these actions as the beliefs of a few individuals. The entire labour movement in Canada must confront how the role of white supremacy is embedded in the institution of the movement. We have a central role in combatting the rise of the far right and stamping it out once and for all. It is necessary to confront imperialism, fascism, and white supremacy head-on. We need an open dialogue in the house of labour; that requires more than press releases or statements from elected officials. It requires resources dedicated to tough conversations with members about the role that white supremacy has played in dividing workers right from the inception of the labour movement.

Extremism plays to the fears of everyday working-class people who face both economic uncertainty and a fabricated sense of loss of identity and freedoms. Much reflection is needed to examine our own spaces to see how right-wing extremism has entrenched itself in the various structures of the labour movement. We are disheartened that these narrow views have overshadowed the critical discussions about racial justice that captured national and international focus, stemming from the rise in anti-Asian racism, the Black Lives Matter movement, and the horrors of residential schools. This consciousness raising among the

10 Sean Richmond, "What Every Canadian Should Remember About the 'Freedom Convoy' Crisis," *The Conversation*, March 21, 2022, https://theconversation.com/what-every-canadian-should-remember-about-the-freedom-convoy-crisis-178296.

general public about the role of Canada as a state and our need to take responsibility for past actions resulting in today's exclusionary policies have been pushed aside. We are having reactionary conversations regarding individual freedoms and white fragility rather than societal responsibilities.

Fighting for racial justice might feel like an emotional roller coaster. We often feel like we have moved one step forward but then take two steps back. However, we see many signs of hope led by workers impacted most by the pandemic. Female workers, Indigenous workers, and other racialized workers are standing up and fighting back. Workers at Amazon and Starbucks, campus workers, gig workers, and precarious workers in multiracial workplaces are organizing, countering the growth of racism by working collectively to improve their lives and working conditions. These struggles are a beacon of light during some very tough and difficult times.

As we continue to organize, we realize this struggle is not limited to our lifetime. It continues with what our elders have instilled in us so we can build on the fight and in turn share the lessons we have learned with future generations. It is essential that our children and those coming after us are equipped with the tools—historical memory of what occurred in the past and knowledge of the struggles that are happening today—so that we are not caught in a vicious cycle of repeating the mistakes of the past. If we are to confront fascism, white supremacy, and the rise of the far right, then we have to learn what our elders have taught us and modify and apply lessons from the past to both current and future struggles.

谷口旅舘

270

NNY TAKAHASHI
LABOR AGENT

Why We Say Powell Street and Not "Japantown"

ANGELA MAY AND NICOLE YAKASHIRO

360 Riot Walk traces the layered histories of Vancouver's labour politics, anti-Asian racism, and community resistance in what is today known as the Downtown Eastside (DTES). One of the tour's key sites is the historic Powell Street neighbourhood, a target of rioters in 1907 and the former hub of the city's Japanese Canadian community before the federal government uprooted and dispossessed thousands of Nikkei (members of the Japanese diaspora) residents in the area, beginning in 1942. Talking and walking about these places may seem like nothing much at all, but we suggest that the ways we do so matter. Even the names we give these places shape how we understand their history, their present, and their possible future. This is why we say Powell Street and not "Japantown."

◀
270 Powell Street, labour agents, 1907. | Library and Archives Canada, Ottawa, PA-067272

WHY DO PEOPLE SAY "JAPANTOWN"?

The name "Japantown" pervades popular media. You can find it on Google Maps, in newspaper articles, podcasts, and up until recently, in the City of Vancouver's heritage documents.[1] One *Daily Hive* story, for example, draws on photographs to depict what the writer describes as "Vancouver Then and Now: Japantown."[2] Even the popular CBC podcast *The Secret Life of Canada* dedicated an entire episode in 2020 to ask: "Where Is Japantown?"[3] To some extent, the use of "Japantown" makes sense. It is an easy-to-recognize moniker that fits within a historical landscape of migrant or "ethnic" enclaves in Vancouver and, more broadly, Canada. Perhaps most well known among these neighbourhoods in Vancouver is Chinatown, a place that has also faced its share of targeted violence and whose residents continue to confront aggressive threats of gentrification.[4] From their very beginnings, white settlers and politicians gave these neighbourhoods—often composed of working-class migrant communities—names like "Japantown" or "Little Tokyo" to mark them

▲
360 Riot Walk tour participant, 2019. | Photo: Henry Tsang

[1] Notable among these resources is the *Historical and Cultural Review: Powell Street (Japantown)*, https://vancouver.ca/files/cov/powell-street-japantown-historical-cultural-review.pdf. Also, see the Vancouver Heritage Foundation's *Historic Map-Guide of Japantown Vancouver*, https://www.vancouverheritagefoundation.org/wp-content/uploads/2020/12/Japanese-Canadian-District-ENGLISH-web.pdf. The City has started to make necessary changes in their terminology in response to community advocacy on this front. See, for example, the updated *Historic Japanese Canadian District, Paueru-Gai, Map-Guide* from 2018, https://www.vancouverheritagefoundation.org/wp-content/uploads/2020/12/Japanese-Canadian-District-ENGLISH-web.pdf.

[2] Andrew Farris, "Vancouver Then and Now: Japantown (PHOTOS)," *Daily Hive*, August 26, 2016, https://dailyhive.com/vancouver/vancouver-then-and-now-japantown-photos.

[3] Falen Johnson and Leah-Simone Bowen, hosts, "Where Is Japantown?" *The Secret Life of Canada* (podcast), May 12, 2020, accessed June 6, 2022, https://www.cbc.ca/listen/cbc-podcasts/203-the-secret-life-of-canada/episode/15776151-s3-where-is-japantown.

[4] See, for example, Vince Tao, "Chinatown Victory at 105 Keefer: VANDU Interviews Vince Tao," *The Mainlander*, March 15, 2018, https://themainlander.com/2018/03/15/chinatown-victory-at-105-keefer-vandu-interviews-vince-tao; Christopher Cheung, "Chinatown in Colour, Before Condos and Coffee Bars," *Spacing Vancouver*, April 8, 2019, http://spacing.ca/vancouver/2019/04/08/chinatown-in-colour-before-condos-and-coffee-bars/; Christopher Cheung, "Young Adults Fuel Chinatown's Future," *Vancouver Is Awesome*, April 17, 2015, https://www.vancouverisawesome.com/courier-archive/news/young-adults-fuel-chinatowns-future-2997459; and Nat Lowe, "Class Struggle in Chinatown: Ethnic Tourism, Planned Gentrification, and Organizing for Tenant Power," *The Mainlander*, July 16, 2019, https://themainlander.com/2019/07/16/class-struggle-in-chinatown-ethnic-tourism-planned-gentrification-and-organizing-for-tenant-power/.

as "foreign" and outside the bounds of white settler society.[5] But these sites were never the sole creation of outsiders. Rather, migrants constructed these neighbourhoods as places of respite and community in spite of the onslaught of anti-Asian racism and other forms of class and race-based marginalization in settler colonial Vancouver. Over time, even the names of these places have been reclaimed by communities and deployed in new ways. Chinatown, for example, has become a name and place around which many Chinese Canadian community organizers have mobilized throughout the twentieth century.[6] These names, then, have become commonplace and appear to many as innocuous and even empowering.

BUT WHY EXACTLY IS "JAPANTOWN" A PROBLEM, THEN?

While we recognize the power of invoking place names for community-organizing purposes, we also question their limitations, specifically in the case of "Japantown" in Vancouver. We find ourselves asking: What does the name "Japantown" obscure? How is "Japantown" used and misused? How has it been deployed, and by whom? Historically, "Japantown" was never used widely among Japanese Canadians living

5 See Kay Anderson, *Vancouver's Chinatown: Racial Discourse in Canada, 1875–1980* (Montreal and Kingston: McGill-Queen's University Press, 1991) and David Chuenyan Lai, *The Forbidden City Within Victoria: Myth, Symbol, and Streetscape of Canada's Earliest Chinatown* (Victoria: Orca Book Publishers, 1991).

6 See Jo-Anne Lee, "Gender, Ethnicity, and Hybrid Forms of Community-Based Urban Activism in Vancouver, 1957–1978: The Strathcona Story Revisited," *Gender, Place & Culture* 14, no. 4, (2007); Steffanie Ling and Jannie Leung, "United Against Neoliberalism: A Conversation on Artists and Organizers in Vancouver's Chinatown," *The Mainlander*, December 7, 2017, https://themainlander.com/2017/12/07/united-against-neoliberalism-a-conversation-on-artists-and-organizers-in-vancouvers-chinatown/; and erica hiroko isomura (artist) and Kaitlyn Fung (essayist), "Poster #30: Another World Is Possible: Intergenerational Resistance in Vancouver's Chinatown," *Remember|Resist|Redraw*, a project of the Graphic History Collective, n.d., https://graphichistorycollective.com/project/poster-30-intergenerational-resistance-in-vancouvers-chinatown%e2%80%a9.

Illustration in City of Vancouver's Downtown Eastside Plan, 2015. | *Vancouver City Council*

in Powell Street before the Second World War.[7] Instead, they more often used "Paueru Gai," "Powell Street," "Powell Grounds," or simply "Paueru." Also, Japanese Canadians were never the only people to live and work in the Powell Street area. The name "Japantown" obscures the presence of non-Japanese neighbours, tenants, co-workers, and friends, never mind those within our community who do not identify with Japan. The neighbourhood has always been diverse and, more importantly, has "long served as a place for people [and communities] facing structural

7 Katsuyoshi Morita, *Powell Street Monogatari* (Burnaby: Live Canada Publishing Ltd., 1989), v; Audrey Kobayashi, *Memories of Our Past: A Brief History and Walking Tour of Powell Street* (Vancouver: NRC Publishing, 1992), 12; Trevor James Wideman and Jeffrey R. Masuda, "Assembling 'Japantown'? A Critical Toponymy of Urban Dispossession in Vancouver, Canada," *Urban Geography* 39, no. 4 (2018): 501; Grace Eiko Thomson, *Chiru Sakura—Falling Cherry Blossoms: A Mother & Daughter's Journey Through Racism, Internment and Oppression* (Prince George: Caitlin Press, 2021), 38.

and quotidian violence in settler colonial Vancouver."[8] As Nikkei artist Andy T. Mori reminds us, "The Nikkei obviously weren't the first to be violently displaced out of the area. The DTES was one the earliest places of Indigenous settlement in what became Vancouver."[9] Moreover, as a result of the forced incarceration, dispersal, and dispossession during the Second World War, Japanese Canadians simply no longer live in Powell Street. This fact, the racist origins of the name, and the multiple erasures the name perpetuates makes calling the Powell Street neighbourhood "Japantown" a problem.

Perhaps most critically, the use of the name risks people's displacement from the neighbourhood. While for some, calling Powell Street "Japantown" is a way to commemorate and claim the neighbourhood as a Japanese Canadian place, others—namely urban planners, policymakers, and politicians at the City of Vancouver—have capitalized on our community's desire to commemorate the neighbourhood to justify gentrification in Powell Street. If we take seriously the power of names and naming, we must reckon with the difficult fact that "Japantown" has been mobilized by the City and by developers in order to "revitalize," "clean up," and "beautify" Powell Street at the expense of people currently living in the area.[10] This kind of "revitalization" project is perverse, because it recognizes the violence and injustice of the uprooting of Japanese Canadians, but in the same move—literally in the name of commemorating wrongdoing to Japanese Canadians—facilitates further

8 Nicole Yakashiro, "'Powell Street Is Dead': Nikkei Loss, Commemoration, and Representations of Place in the Settler Colonial City," in "Loss and the City," special issue, *Urban History Review* 48, no. 2 (2021): 42.
9 Aaron Franks et al., "The Right to Remain: Reading and Resisting Dispossession in Vancouver's Downtown Eastside with Participatory Art-Making," *feral feminisms* no. 4 (2015): 44.
10 Masumi Izumi, "Reclaiming and Reinventing 'Powell Street': Reconstruction of the Japanese Canadian Community in Post–World War II Vancouver," in *Nikkei in the Pacific Northwest: Japanese Americans and Japanese Canadians in the Twentieth Century*, eds. Louis Fiset and Gail M. Nomura (Seattle, WA: University of Washington Press, 2005); and Jeffrey Masuda and Aaron Franks, "The Right to REMAIN in Vancouver's Nihonmachi/Downtown Eastside," *The Bulletin/Geppo*, May 11, 2014, https://www.jccabulletin-geppo.ca/the-right-to-remain-in-vancouvers-nihonmachidowntown-eastside.

LEGEND

- Area Boundary
- Streets
- Railway
- Existing Greenway/Bikeway
- Parks and Open Space
- New/Improved Walking/Cycling Route
- Potential Walking Connection
- Potential Access over Rail Improvement
- Proposed Pedestrian Improvement Focus Area
- Chinatown National Historic Site

Establish Economic Centre
- Enhancement
- Revitalization

Other Economic Action
- Emphasize Pedestrian-Oriented Active Uses At-Grade
- Facilitate Local-Serving Retail/Services
- Strengthen Industrial Economy and Job Creation
- Opportunities
- Primary Retail/Service Corridor
- Community-Based Development Area

violence and injustice by displacing low-income, often Indigenous, racialized, disabled, and gender nonconforming people who live in the neighbourhood.

The problem of the term "Japantown," then, is both straightforward and complicated. The name proposes a kind of Japanese Canadian commemoration that lays the groundwork for further violence in the neighbourhood: it commemorates Japanese Canadian presence and facilitates other people's absence. In Vancouver, should we continue to use the name "Japantown," we would be complicit in yet another iteration of violent displacement in the very place from which we were once forcibly removed. Saying Powell Street and not "Japantown" reflects our refusal to take part in that displacement and our commitment to reckoning with the consequences of our community's history-telling.

BUT CAN A NAME REALLY CAUSE HARM?

Yes—and we are far from the first to raise concerns about the name "Japantown." For decades, a wide range of Japanese Canadian academics, artists, and writers have considered this very issue, and yet, it remains an ongoing problem. For instance, from 2012 to 2015, geographers Jeff Masuda, Audrey Kobayashi, and Aaron Franks led a research project called *Revitalizing Japantown? A Unifying Exploration of Human Rights, Branding, and Place.* These scholars explicitly questioned the politics of place names in Powell Street and, alongside a team of other researchers, artists, activists, and organizers in the Japanese Canadian and DTES communities, were able to interrogate how "Japantown" was mobilized in urban planning.[11] They found that, by and large, the use of the name

◀
Drawing of "Potential Development Opportunities and Policy Proposals" in City of Vancouver's Downtown Eastside Plan, 2015. | *Vancouver City Council*

11 Trevor J. Wideman and Jeffrey R. Masuda, "Toponymic Assemblages, Resistance, and the Politics of Planning in Vancouver, Canada," *Environment and Planning C: Politics and Space* 36, no. 3 (2018): 383–402.

"Japantown" was synonymous with the desire to gentrify Powell Street, paving the way for displacement across the neighbourhood.[12] The project located the specific origins of the place name "Japantown" in the 1980s when the City of Vancouver sought to create a "Japanese Village" in the DTES in the name of "beautification."[13] Decades later, in 2012, even the City's Local Area Planning Process, an initiative said to address issues of homelessness and displacement in the DTES, "appropriate[d] [Japanese Canadian] history to advance an exclusionary 'Japantown' revitalization agenda."[14]

For many within the Japanese Canadian and DTES communities, this "revitalization" agenda was wrong. As the *Revitalizing Japantown?* museum exhibit catalogue later put it, "The DTES is its people, and the people of the DTES do not need to be 'revitalized' because they are already vital."[15] This sentiment echoes earlier work from Audrey Kobayashi in which she underscores the DTES community's "vibrancy and rhythm" and stresses how they too are "undergoing a dispossession, daily eroded as the pressures of rising property values yield more and more buildings to the avarice of developers."[16] As Nikkei scholars who owe much to the scholarship and activism of Japanese Canadians before us, what we articulate here is an expression of our inheritance: the place name "Japantown" must be refused.

12 Wideman and Masuda, "Assembling 'Japantown'?"; Wideman and Masuda, "Toponymic Assemblages."
13 Jeffrey R. Masuda et al., "After Dispossession: An Urban Rights Praxis of Remaining in Vancouver's Downtown Eastside," *Environment and Planning D: Society and Space* 38, no. 2 (2019): 6.
14 Wideman and Masuda, "Assembling 'Japantown'?," 509.
15 Nikkei National Museum & Cultural Centre, *Revitalizing Japantown? A Unifying Exploration of Human Rights, Branding, and Place* (Burnaby: Nikkei National Museum & Cultural Centre, 2015), 8.
16 Kobayashi, *Memories of Our Past*, 9.

SO, WHAT'S NEXT?

We move forward by questioning the names we use to describe the places we inhabit and move through—including the places featured in *360 Riot Walk*. At stake are the lives and livelihoods of people now dwelling in the Downtown Eastside. We cannot advocate for justice or redress without addressing the ways injustice is perpetuated in our community's name or in the name "Japantown." To attend to the meanings inherent in *360 Riot Walk* and to think through the question posed by artist Henry Tsang of who has the right to live here—both in the Downtown Eastside and on all unceded xʷməθkʷəy̓əm (Musqueam), Sḵwx̱wú7mesh (Squamish), and səlilwətaʔɬ (Tsleil-Waututh) lands—we need to grapple with the fact that how we inhabit places and the names we give them are not benign. On the contrary, the ways that we take up and name spaces are meaningful decisions and forces. Words and names *do* things. Even as we advocate for the name of "Powell Street" or "Paueru Gai" in lieu of "Japantown," we know this name is far from perfect itself. Powell Street itself was named after Israel Wood Powell, Superintendent of Indian Affairs in British Columbia from 1872 to 1889, a fact which prompts us to further question the politics of names and commemoration in settler colonial Canada. What and whom does the name "Powell Street" obscure?

But the thing about names is that we can change them. We can adapt. We know that the name "Japantown" does things and that the things that it does are violent. We refuse to let our history be weaponized against the Downtown Eastside. Some may read this and ask what the Japanese Canadian community might lose by rejecting the name "Japantown." We ask, instead, what we—and so many others—can gain. This is why, at least for now, we say Powell Street and not "Japantown."

122 Powell Street, 1907. | Library and Archives Canada, Ottawa, PA-067275

"*Have We a Dusky Peril? Hindu Hordes Invading the State,*" article from Puget Sound American, September 16, 1906.

The Bellingham Riot

PAUL ENGLESBERG

Organized labour and labour-affiliated Asian exclusion organizations instigated mob violence on both sides of the border in the fall of 1907, most notably the riots in Vancouver, Canada, and in Washington state in the United States. Although rioters in Vancouver attacked the Chinese and Japanese communities, in Washington state the mobs primarily targeted and drove out men from Punjab, India. These immigrants were called "Hindus" in the newspapers and by government officials, but in fact, most were Sikhs from the Punjab region.

The focus of this essay is on the riot against South Asians in Bellingham, a city located close to the US-Canada border, and how the forced expulsion of Punjabis from Bellingham contributed to anti-Asian fervour and emboldened activists along the Pacific Coast.[1] These riots resulted from labour and nativist activism which "emerged from the mass and concerted politics of anti-Asian agitation."[2] Furthermore, as historian David Atkinson demonstrated,[3] these racially motivated attacks and exclusion drives all had profound international repercussions and fuelled efforts in Canada and the United States to further restrict immigration of Asians.

1 Joan M. Jensen, *Passage from India: Asian Indian Immigrants in North America* (New Haven: Yale University Press, 1988).
2 Kornel Chang, *Pacific Connections: The Making of the U.S.-Canadian Borderlands* (Oakland: University of California Press, 2012).
3 David C. Atkinson, *The Burden of White Supremacy: Containing Asian Migration in the British Empire and the United States* (Chapel Hill: University of North Carolina Press, 2016).

"Hindus Hounded from City,"
front page of Bellingham Herald,
September 7, 1907.

THE "ANTI-HINDU RIOT" IN BELLINGHAM, WASHINGTON

On the evening of September 4, 1907, in Bellingham, a mob attacked and drove out several hundred labourers from India. There had been a series of warnings and attacks in the days before. After a massive Labour Day parade and gatherings of workers, labour leaders issued threats, and several violent incidents broke out against Punjabis.[4]

The goal of the rioters was to force South Asian workers out of the lumber mills and the city using the threat of force and actual beatings and to round up the men from their beds and the mills. Overnight, over a hundred were herded into the city jail in the basement of the City Hall per an agreement worked out with the police chief. Within a few days, the mob's goals were fulfilled; nearly all South Asian workers and job seekers had left either by train or steamship for points farther south along the Pacific Coast or on foot to cross into Canada. According to spokesmen for the group, many took the threats seriously and were afraid for their lives. Although local papers downplayed their injuries, a disputed wire dispatch reported that six were badly beaten and hospitalized.[5]

The rioters were said to number at least five hundred, and accounts describe a mob that grew and separated into smaller groups throughout the night, some attacking living quarters and other marching to lumber mills. Five men were arrested and jailed, and police handcuffed two others described as boys but released them when surrounded by the mob. The five arrested rioters were later released and never indicted, as the prosecutor claimed that no witnesses willing to testify could be

4 "Mob Raids Hindus and Drives Them from City," *Morning Reveille* (Bellingham), September 5, 1907.
5 "Mob Drives Out Hindus," *New York Times*, September 5, 1907.

found.[6] As the immigrants from India were considered British imperial "subjects," the British vice-consul visited Bellingham to investigate the attack. No further action on behalf of the victims of the riot was taken by the British officials, who questioned their responsibility based on the 1815 commerce treaty between the United States and Great Britain.[7]

The riot was the first in a series of attacks on Punjabis from India in Washington state and in British Columbia, but it was not the first anti-Asian action in the Bellingham area. In October 1885, an anti-Chinese movement expelled Chinese residents from the towns that would later combine to form Bellingham. In August 1905, in the nearby border town of Blaine, fighting in the cannery led to an attack on Japanese workers by "a furious mob." Fearing further violence and inadequate protection, officials of the Japanese Consulate decided to relocate the Japanese workers, numbering about a hundred, from Blaine to Portland, Oregon.[8]

Fears of invasion and hostility arose as South Asians began to arrive in the Bellingham area in early 1906. A year preceding the riot, approximately twenty South Asians were working in lumber mills and on a street paving project; some mill workers demanded they be fired, and the press raised fears of a "dusky peril."[9] City arrest records suggest a pattern of police harassment and discriminatory treatment.

A.E. Fowler, secretary of the Seattle branch of the Asiatic Exclusion League (AEL), arrived in Bellingham on September 6 on his way to Vancouver, BC, where he spoke at the local AEL demonstration the next day. Some Canadians blamed his impassioned speech, in which he invoked the Bellingham riot, for sparking the ensuing Vancouver riots. Fowler had previously sent a letter to President Roosevelt urging

6 "Alleged Rioters Are Released from Custody," *Bellingham Herald*, September 21, 1907.
7 Atkinson, *The Burden of White Supremacy*, 100.
8 Untitled editorial, *Blaine Journal*, August 11, 1905; "Japs Evacuate Scene of Riot," *Bellingham Herald*, August 11, 1905.
9 "Have We a Dusky Peril?" *Puget Sound American*, September 16, 1906.

"immediate action" to block Asian immigration and warning that otherwise, "the agitation started in Bellingham would spread all over the Sound country and massacres of the Eastern aliens was likely to result."[10]

After the Bellingham riot, press reports identified both immediate and long-standing grievances that were attributed as causes. Primary were economic threats to mill jobs and wages, as South Asian labourers were believed to be willing to work for lower wages than the prevailing rate for European Americans. A further complaint was that Punjabi workers spent little, lived very frugally, and saved much of their pay to send to family in India. Immediate grievances mentioned as triggering the violence were several South Asian men refusing to yield the sidewalk to women, boisterous fighting by South Asians outside of taverns, and a white female tenant being displaced by "Hindu" men. The lumber mill owners who employed South Asian workers were named as the ultimate culprits by the Bellingham City Council in a controversial resolution.[11] By September 17, the last few remaining residents from India were evicted, and for many decades, people from South Asia mostly avoided Bellingham and Whatcom County. It was not until the late 1980s and 1990s that some Sikh families began to move to the area, and by 2020, the Punjabi Sikh community in Whatcom County had grown to about four thousand people.

10 "Exclusion League Demands a Check," *Morning Reveille*, September 6, 1907.
11 Bellingham City Council Proceedings Vol. 4, "Report of Committee as a Whole," September 9, 1907, 483; "Mill Owners Are Censured by Council," *Morning Reveille*, September 10, 1907, 1.

BOYCOTT

A General Boycott has been declared upon all CHINESE and JAPANESE Restaurants, Tailor Shops and Wash Houses. Also all persons employing them in any capacity.

All Friends and Sympathizers of Organized Labor will assist us in this fight against the lowering Asiatic standards of living and of morals.

AMERICA vs. ASIA
Progress vs. Retrogression
Are the considerations involved.

BY ORDER OF
Silver Bow Trades and Labor Assembly and Butte Miners' Union

Flyer distributed by Silver Bow Trades and Labor Assembly and Butte Miners' Union in support of Chinese and Japanese immigration boycott, ca. 1898. | National Archives (US), College Park, 298113

WIDESPREAD ANTI-ASIAN VIOLENCE, 1907–08

The Bellingham riot was but one of many acts of violence against Asians in 1907 on the Pacific Coast. Riots and violent conflicts occurred in San Francisco and Live Oak in California, and in Seattle, Danville, and Everett in Washington state.

San Francisco

In San Francisco, much controversy and conflict had been stirred up in 1905 over the segregation of the small number of Japanese students in public schools, resulting in the boycotting of Japanese-owned restaurants by whites in 1906 and the stoning of some of these restaurants the following year. On May 21, 1907, a riot broke out against the Japanese, sparked by a fight at a Japanese-owned restaurant, with several Japanese businesses being damaged. The outbreak of violence could be traced to provocations by labour unions, the AEL, and the anti-Asian bias of the local press.[12]

Seattle

In Seattle, two attacks occurred against Punjabis following the riots in Bellingham and Vancouver. On the evening of September 13, 1907, thirty-two Punjabis, some of whom had fled from the Bellingham mob, boarded a steamship heading to Valdez, Alaska, in search of work. When white passengers boarded a few hours later and found that they would be travelling with the immigrants, they immediately organized an "indignation meeting … during which excited passengers urged each other to throw the Hindus into the bay." After demanding that the captain remove the Punjabi passengers, "someone seized a Hindu

[12] "The Attacks on Japanese from a Special Correspondent," *Outlook*, June 29, 1907.

and pushed him down the gangplank ... another was unceremoniously thrown over the rail to the pier. The rest followed without protest."[13] The ship left the Punjabis and their baggage on the pier before heading north to Alaska.

Two days later, on September 15, 1907, a "small riot" occurred between a group of fourteen Punjabis (who may also have fled Bellingham) and over twenty Swedes, who were "taunting and jeering" at the Punjabi men. Some men were injured with knife wounds, and some of the Punjabis used axes to break down a door to where the Swedes had fled. Five of the Punjabis were arrested by police and later fined for being drunk and disorderly.[14]

Danville

Ten Punjabi men crossed the border from British Columbia seeking work in a lumber mill in Danville, Washington. On the night of October 3, rioters attacked them in their cabin with a hail of rocks and gunshots, and three were struck by rocks. The men were forced to flee back to Canada. No one was arrested for the violent attack.[15]

Everett

Located fifty kilometres (thirty miles) north of Seattle, Everett had a population of approximately 27,000 in 1907.[16] By the summer of 1907, over forty Punjabis were employed in three lumber mills, and some labour leaders were calling for the trades council to limit further hiring of "Asiatic labor" and for a "general strike" or other unspecified

Handbill distributed in Tacoma, Washington, 1892. | *Washington State Historical Society, Tacoma, 1903.1.200*

13 "Hindus Driven Off Alaskan Boat," *Bellingham Herald*, September 14, 1907.
14 "Hindus in Fight with Swedes," *Seattle Star*, September 16, 1907; "Hindus Fined," *Seattle Star*, September 17, 1907; "Swedes in Seattle Mix Up with Hindus," *Tacoma Daily Ledger*, September 16, 1907.
15 "Race Riot," *Seattle Star*, October 4, 1907; Untitled article, *Spokane Daily Chronicle*, October 4, 1907.
16 "Population Is 26,930," *Everett Daily Herald*, July 6, 1907.

"action."[17] The trades council set up a committee to organize a local branch of the AEL.[18] American Federation of Labor organizer C.O. Young addressed a mass meeting of mill workers on "how to eliminate Hindu labor from Everett."[19] He organized a new affiliate, the Mill Workers' Union, announced plans to organize hundreds of workers to march in the Labour Day parade, carrying banners that proclaimed, "Mill men, take your choice between the Hindu labor and the white man," and "The Hindu Must Go," and sent a demand to mill owners to fire Punjabi workers or "suffer the consequences."[20] Young characterized the upcoming effort as "a crusade for the white working man" to be conducted "without force or intimidation of any character."[21]

Immediately following the Labour Day parade and the riot in Bellingham on September 4, forty-one Punjabis sent a petition to Bernard Pelly, British Vice-Consul in Seattle, asking for protection because, as they wrote, "we fear that bodily violence will be done to us."

> Fearing that we will not receive adequate protection from the city, county or state authorities, we appeal to you to extend us what aid lies in your power, for if we receive no protection from you, or from the Federal authorities upon your request, we will suffer serious bodily injury and be deprived of our livelihood.[22]

The British Consulate made inquiries to Mayor Newton Jones and received assurances that the Punjabis' fears were "unwarranted," that

17 "Everett Millman Object to Hindus," *Morning Reveille*, June 29, 1907; "Hindoo Labor Invades State," *Spokane Press*, June 29, 1907.
18 Untitled article, *Seattle Star*, August 2, 1907.
19 "Shut Out Hindus," *Spokane Chronicle*, August 19, 1907.
20 "Millmen Form an Organization," *Everett Daily Herald*, August 15, 1907.
21 "To Organize Mill Workers," *Everett Daily Herald*, August 14, 1907.
22 Petition from the Indian residents of Everett, September 5, 1907, FO 371/360 no. 30029, National Archives, London.

the labour leaders might call a strike but would not break the law. Jones pledged to protect the life, liberty, and property of all, but urged the British to discourage any further immigration of people from India.[23]

Despite such assurances, two months later, on November 2, a mob of "several hundred white laboring men and boys" assembled with the intent of driving out all Punjabi workers from the city. The first targets were the three lumber mills where Punjabi workers were employed; however, armed guards blocked the rioters at the mill gates. The mob then turned to the living quarters of the workers, hurling rocks, breaking windows, firing shotguns, and destroying some of the residences. Police Chief Scott M. Marshall had received a tip in advance of the planned attack and ordered the police to bring thirty-four of the Punjabis to the city jail before any of them could be physically attacked. By midnight, the remaining rioters had gathered outside of City Hall, which housed the jail, shouting "Down with the Hindus!" Mayor Jones emerged to address the mob, explaining that the city was protecting the workers and asking those assembled to disperse. On the following night, fearing further attacks, most of the Punjabi workers returned to the jail. The local newspaper reported that because they were "refusing to eat of the white man's cooking, they were supplied with boxes of apples for food."[24]

By Tuesday, November 5, most had left on the train for Portland, Oregon, claiming that "they had been abused and misunderstood … On the station platform they argued in bent if not broken English that they were not undesirable citizens and inferred that the white man would be sorry some day for having treated them with contempt."[25] None of the rioters was arrested by police or charged for the mob violence.

Pedestrians and wagons on the street by Vancouver City Hall, ca. 1900. | Photo: Philip Timms. Vancouver Public Library, 3428

23 "Everett Hindus Appeal to the British Consul for Protection," *Everett Daily Herald*, September 16, 1907.
24 "Mob Scares Everett Hindus," *Everett Daily Herald*, November 5, 1907, 1, 4.
25 "Last of Hindus Go," *Everett Daily Herald*, November 6, 1907.

The editorial opinion was similar to that following the Bellingham riot: decrying violence and praising the work of the police in preventing further violence, but blaming the mill owners for employing Asian immigrants and agreeing with the aims of the rioters to rid the community of the immigrants. The *Everett Daily Herald*'s two-sided opinion of regret and racial animus was summed up in its editorial column:

> Only regret can be expressed for Saturday night's demonstration against the Hindus in Everett ... The truth of the matter is that the whole story is told when it is said that this "is a white man's country." We feel that we can't assimilate the Hindus, and we don't wish to try ... Everett does not wish the Hindus, but it wants no violence in getting rid of them.[26]

Live Oak

On the night of January 26, 1908, a vigilante committee drove out seventy-eight Punjabi railroad workers from two houses in Live Oak, California. In attempting to justify the expulsion, the vigilantes complained that the immigrants were "undesirable" and "had been guilty of indecent exposure in the presence of women and children." Two of the rioters were arrested for allegedly robbing close to two thousand dollars from the Punjabis, but after a preliminary hearing, the case was dismissed.[27]

26 Untitled editorial, *Everett Daily Herald*, November 4, 1907.
27 "Hindus Driven Out of Live Oak...," *Marysville Evening Democrat*, January 27, 1908; "Live Oak People Drive Out Hindus," *Sacramento Bee*, January 27, 1908; "Hindus Fail to Have Whites Held," *Sacramento Bee*, January 30, 1908; "Drive Hindus from Town for Indecency to Women," *San Francisco Call*, February 2, 1908.

CONCLUSION

The Bellingham riot was an important example of the xenophobic and racial attacks against Asians that were prevalent in the United States and Canada at the time. The forced expulsion of hundreds of people from the community encouraged other attacks on South Asians and had a profound influence on immigration policy. In both countries, immigration hawks cited the widespread violence as proof that the citizenry in the region strongly supported their call for the exclusion of Asian immigration. Tepid government response to such riots, alongside the racially charged rhetoric in the English language press, clearly demonstrated the white nationalist attitudes that prevailed along the Pacific Coast of Canada and the United States in the late nineteenth and early twentieth centuries.

City Council hearing on 105 Keefer, 2017. | *Photo: Melody Ma*

A Changing Chinatown: On Gentrification and Resilience

MELODY MA 馬勻雅

Next to the steaming windows of an Instagram-worthy café, young twentysomethings in beanies coddle their hot lattes. Down the street, a lineup snakes outside a streetwear shop for the latest sneaker drop. A DoorDash bike courier speeds by, carrying a steaming vegan pizza he just picked up from around the corner.

This scene could be in just about any bustling North American city today. But the flaring red dragon lampposts, the looming century-old Chinese Benevolent Association buildings, and the waft of Chinese barbecue pork reminds us that we're situated in Vancouver's Chinatown—a gentrifying Chinatown.

Over a hundred years ago, Chinese labourers from six rural areas of Guangdong, the southern province of China, migrated to Canada's West Coast. In search of jobs and better wages, these men toiled away on the Canadian Pacific Railway, on farms, and in canneries.

Separated from their families, they slept in shifts in rooming houses above Canton Alley. Together, this early group of Chinese migrants created the dozen blocks we call Chinatown today. They set up shops, restaurants, and societies to support each other, despite being away from their kin.

However, the presence of Chinese migrants was not welcomed by everyone. In 1885, the federal government introduced a Chinese head tax

Head tax certificate for Lee Shing Dok, 1913. | Department of Employment and Immigration fonds, Library and Archives Canada, Ottawa, 161424 e011074369-v8

Lao Tzu (Laozi) mural at 313 East Pender Street, 2014. | Photo: Richard Eriksson

aimed to halt Chinese immigration. The Chinese Immigration Act was passed in 1923, further limiting the possibility of any family reunification. Despite the racist state-directed efforts to eradicate them, the Chinese community remained steadfast and resilient in Chinatown. The presence of the neighbourhood to this day is a mark of the community's strength.

Today, Chinatown faces a new threat: gentrification. Gentrification is a powerful displacing force creating crisis in the communities we live in. It is a process of class displacement wherein an influx of wealthy people displaces the existing poor.

The trail signs of gentrification are familiar: Cafés get a little fancier. A new grocer moves in, selling nine-dollar juice. The faces on the street start to look different. Rents hike upward. The sights, smells, and sounds of the neighbourhood change. Local residents find themselves excluded from places that used to be their old haunts. Slowly but surely, an unfamiliar neighbourhood emerges.

Though Vancouver's Chinatown is recognized as a national historic site in Canada, the neighbourhood has been squeezed by the intense pressure of gentrification over the last decades, along with the rest of Vancouver's Downtown Eastside. Alongside class displacement, Chinatown faces another threat: the erosion of its distinct cultural heritage and history.

Take, for example, the fate of the magnificent three-storey mural of Chinese philosopher Lao Tzu (also known as Laozi) astride an ox that is painted on the side of the hundred-year-old Lee Association Building. Now, the original mural is hidden by a bright-gold micro-suite condo tower at 303 East Pender Street called Brixton Flats that boasts a cold-pressed juice and coffee lounge on the ground floor. A budget-friendly Hong Kong–style café on Main Street has been supplanted by a hip

akes knowledge to understand others,
it needs a clear mind to know oneself
es strength to surpass others,
requires a strong will to surpass oneself.

Lao Tsu

知人者智，自知者明。
勝人者有力，自勝者強。
——老子

Brixton Flats at 303 East Pender Street, 2022. | *Photo: Melody Ma*

pizza shop. Affordable, culturally appropriate greengrocers lining Gore Avenue are replaced by millennial-aesthetic boxing gyms that cater to the gentry, resulting in the loss of valuable cultural food assets.[1]

The combination of economic and cultural displacements resulting from the building of new housing and amenities that cater to a new, wealthier demographic creates "zones of exclusion."[2] Long-time residents no longer feel welcome in their own neighbourhood. Gentrification and cultural erasure are contemporary versions of the historical anti-Asian riots and Chinese head tax, and they are just as violent and exclusionary in displacing people and their lives.

But the Chinatown community is not known to sit on the sidelines. Repeatedly throughout history, the community has risen and pushed back against forces seeking to eliminate its place.

In the 1960s, moving cars efficiently was all the rage in North America. The urban planning philosophy of the day encouraged cities to build freeways to facilitate the movement of cars. In Vancouver, the drive for urban renewal led to a proposal for a freeway to be constructed through Chinatown and the surrounding Strathcona neighbourhood. This resulted in the formation of the Strathcona Property Owners and Tenants Association (SPOTA); members rallied and fought vehemently against the destruction of their home and, unlike their counterparts in most other cities, succeeded. Their tenacity helped save Chinatown, although the Black community's Hogan's Alley was demolished to build a viaduct.

Decades later in 2017, multiple generations banded together to push back against a shiny new condo tower proposed for 105 Keefer, situated

[1] *Vancouver Chinatown Food Security Report*, Hua Foundation, August 2017, https://huafoundation.org/wp-content/uploads/2020/05/Report_VancouverCTFoodSecurity.pdf.
[2] *Gentrification Produces Zones of Exclusion for Low-Income Residents*, Carnegie Community Action Project, http://www.carnegieaction.org/zones-of-exclusion/, accessed on October 5, 2022.

right next to the Chinatown Memorial Monument for Chinese labourers who built the national railroad and Chinese war veterans who fought for Canada, despite not being recognized as citizens. Multi-generational activism against the real estate development proposal sparked protests and an unprecedented turnout of community members and allies for three days of City Council public hearings on the project. The fight brought all corners of the community together, including Chinese Canadian veterans, Yarrow Intergenerational Society for Justice, the Chinese Cultural Centre, Youth Collaborative for Chinatown, #SaveChinatownYVR,[3] and many others. The power of collective community resistance led to the eventual government rejection of the development.

Both battles, over the freeway and 105 Keefer, were watershed moments for Chinatown. They demonstrated that there was a fighting chance the neighbourhood could be saved by the same resilient spirit our forefathers had when they fought for their survival more than a century ago.

The story of Chinatown isn't finished. As I write this, the global COVID-19 pandemic has created an onslaught of new challenges for the neighbourhood. With anti-Asian hate on the rise, that same racist sentiment toward Chinese people and Chinatown is replayed again and again like a broken record. Asian people are being attacked and killed simply because of the colour of their skin. Artist Shu Ren (Arthur) Cheng's mural at the intersection of Columbia and East Pender, *Snapshots of History*, was defaced with grotesque blotches of red paint meant to look like bullet wounds on the foreheads and bodies of the Chinese pioneers depicted. Long-established Chinatown shops and restaurants like the Goldstone Bakery, which served as a community hub, have shuttered.

Rally against the rezoning of 105 Keefer. | *Photo: Melody Ma*

3 #SaveChinatownYVR was a digital activism campaign I led that encouraged people to participate in Chinatown advocacy, including protesting the 105 Keefer development project.

But at the same time, throughout the pandemic, we saw the steadfast resilience of the Chinatown community in full force. When lockdowns began, youth immediately came together to organize a grocery delivery program for neighbourhood seniors called the Chinatown Cares Grocery Delivery Program that is running to this day. Community members successfully advocated for a culturally appropriate local vaccination clinic that prioritized the most vulnerable. And amid the crisis, the community found the time and energy to resurrect, after a fifty-year hiatus, the Fire Dragon Festival, celebrating the legendary fire dragon dance that wards off plagues.

Some critics say that Chinatown advocates should move on from the past and stop trying to resist the supposed economic growth and development that's coming to the neighbourhood. But they don't understand how Chinatown represents our way of life, our cultural identity, and our living heritage and history, which have been passed on for generations since our ancestors arrived as labourers on this land. For over a century, we have fought for the survival of our people and for our place, and we will continue to fight for Chinatown to endure.

◀

Rally against the rezoning of 105 Keefer. | Photo: Melody Ma

Census Making and City Building: Data Perspectives on the 1907 Anti-Asian Riots and the Development of Vancouver

ANDY YAN

Data is a spyglass that can be used to navigate the oceans of time where few other tools of inquiry traverse, yet its lens is far from infallible and not without its own distortions. Critical, open, and fresh eyes from the present can help create a sharper image of the past and the lessons that can be learned from it. The Canadian Census is one such instrument through which the 1907 anti-Asian riots of Vancouver can be framed to contribute toward a dialogue on relationships of race, data, and city building. When placed in context with the events and politics of the times, it helps us reconsider how the City of Vancouver and the nation defined who belongs and who does not. For the purposes of this article, I will be focusing on Vancouver's Chinese population and Chinatown in particular, while acknowledging the limited capacity here to examine the parallel stories and experiences of the Japanese, South Asian, Indigenous, Hawaiian, and Black populations, and the need for rectification and reconciliation of the forces and policies affecting the xʷməθkʷəy̓əm (Musqueam), Sḵwx̱wú7mesh (Squamish), and səl̓ilwətaʔɫ (Tsleil-Waututh) Nations who have been on this land since time immemorial.

On the surface, a demographic examination of the City of Vancouver that frames the 1907 riots seem straightforward—just look up the data. The internet has made it significantly easier to acquire historical

Anti-Chinese sugar advertisement, 1890. | *University of British Columbia Library, Chung Collection, Vancouver,* CC-GR-00010

Census figures from 1901 and 1911 via the Library and Archives Canada and Internet Archive Canada websites. A quick search provides quick answers, but not necessarily deep or critical insights into how demographics are defined and the political contests that are built within them. When data is placed within the definitions and collection techniques of times that created them, socially constructed ideas of race, ethnicity, and nationhood become evident, as the immutability of data objectivity and measurement becomes problematized.

The 1901 Census of Canada took place just fifteen years after the founding of the City of Vancouver in 1886, which experienced its first anti-Asian riot on February 24, 1887.[1] Its first mayor was real estate insider Malcolm MacLean, who ran on a platform which included restricting property rights for the Chinese. Two years prior, in 1884, the Chinese had been excluded from pre-exemption in British Columbia, meaning that unlike European settlers, Chinese and Indigenous populations could not claim unsurveyed and unimproved Crown land.[2] The first official federal Census for the new city, with its 13,685 residents, was 1891. By 1901, the population grew to 27,010, and by 1911, it was 100,401. Between 1891 and 1901, the total population of Vancouver nearly doubled, and from 1901 to 1911, it tripled again.

The handbooks issued to census enumerators for the 1901 and 1911 Censuses provide insight into the ethnocultural and racial attitudes of the time. Under "racial or tribal origins," "British" groupings included subcategories like English, Irish, and "Scotch." European identities included French, Greek, Austro-Hungarian, and German and were

◄
Vancouver's first City Council meets in a tent after the Great Fire of 1886. | *Photo: Louis Denison Taylor. City of Vancouver Archives, 1477-419*

1 Robert A.J. McDonald, *Making Vancouver: Class, Status and Social Boundaries, 1863–1913* (Vancouver: UBC Press, 1996); Kay Anderson, *Vancouver's Chinatown: Racial Discourse in Canada, 1875–1980* (Montreal: McGill-Queen's University Press, 1991).
2 Government of British Columbia, *An Act to Prevent Chinese from Acquiring Crown Lands*, February, 18, 1884, Chung Collection, University of British Columbia Library.

152 — WHITE RIOT

mixed with "Hindu," the only religious category and presumably a generic identity for migrants from South Asia. There was also "Negro," Chinese, Japanese, and "Indian"—presumably for those who were Indigenous.[3] Such Census categories reflect the chaotic nature of early-twentieth-century Canadian understandings of British empire and colonialism, ethnicity, nationalism, race, and religion. They also highlight what American sociologists Michael Omi and Howard Winant call "racial formation," wherein racial categories are "created, inhabited, transformed, and destroyed," as well as a functional and apt definition of race as "a concept which signifies and symbolized social conflicts and interests by referring to different types of human bodies."[4]

Prior to the completion of the Canadian Pacific Railway (CPR) in 1886, it was far more economical to bring in labourers on ships from Asia than it was to use the overland wagon route from Eastern Canada.[5] In 1885, only one-third of British Columbia's population of 49,459 people were European, whereas two-thirds were First Nations and Chinese.[6] Once trans-Pacific shipping routes were established, there followed a systemic series of legislative, political, and diplomatic efforts to restrict and ultimately ban migration from China, Japan, and India.[7]

Societal and economic exclusion of the Chinese and other racialized minorities was further entrenched by a series of race- and class-based exclusions from professions like law and engineering. And democratic

◀

North side of the intersection of Pender Street and Carrall Street, ca. 1910. | City of Vancouver Archives, 371-2116

3 Census Office, Department of Agriculture, *Fourth Census of Canada 1901: Instructions to Chief Officers, Commissioners and Enumerators* (Ottawa: Government Printing Bureau, 1901); Census Office, Department of Agriculture, *Fifth Census of Canada 1911: Instructions to Chief Officers, Commissioners and Enumerators* (Ottawa: Government Printing Bureau, 1911).
4 Michael Omi and Howard Winant, *Racial Formation in the United States: From the 1960s to the 1990s* (New York and London: Routledge, 1994).
5 Henry Yu, "Global Migrants and the New Pacific Canada," *International Journal* 64, no. 4 (2009): 1011–1026.
6 Lisa Rose Mar, *Brokering Belonging: Chinese in Canada's Exclusion Era, 1885–1945* (New York: Oxford University Press, 2010).
7 W. Peter Ward, *White Canada Forever: Popular Attitudes and Public Policy Towards Orientals in British Columbia* (Montreal and Kingston: McGill-Queen's University Press, 1990); Patricia E. Roy, *A White Man's Province: British Columbia Politicians and Chinese and Japanese Immigrants, 1858–1914* (Vancouver: UBC Press, 1989).

disenfranchisement from voting and exclusion from elected political office was enacted in 1885; it would not be repealed until 1947 for the Chinese and 1949 for the Japanese.[8] In the face of this form of political exclusion, there lies a rich, complicated, and turbulent internal community life. In *Brokering Belonging: Chinese in Canada's Exclusion Era, 1885–1945*, historian Lisa Mar writes of how the Chinese in British Columbia were "more than excluded victims or resisting outsiders" and had a deep series of transnational and domestic political, social, and economic lives that are only now being shared.[9]

In the 1901 Census, the only the grouping of "Chinese and Japanese" was found under the category "origins of the people." The Chinese and Japanese populations were aggregated into a single population that numbered 2,870 individuals, or 10.6 per cent of the City's total population in 1901, from a total population of 27,010 residents.[10]

In 1911, the Census began to identify Chinese and Japanese separately. There were 3,559 Chinese and 2,036 Japanese out of a total population of 100,401 residents in the City of Vancouver, which translated to 3.5 and 2 per cent respectively, a total of 5.5 per cent of the population. The proportion of Vancouver residents who were either Japanese or Chinese declined from 10.6 per cent in 1901 to 5.5 per cent in 1911; though the number of Chinese and Japanese grew by 94 per cent, the proportion declined relative to the growth of the general population.[11]

While the population of Chinese and Japanese doubled in Vancouver between 1901 and 1911, the gender imbalance was particularly acute.

▲

The Le Wan Nian Cantonese Opera troupe, 1923. | *Photo: Cecil B. Wand. University of British Columbia Library, Chung Collection, CC-PH-10648*

8 Carol F. Lee, "The Road to Enfranchisement: Chinese and Japanese in British Columbia," *BC Studies* 30 (1976): 44–76; Wing Chung Ng, *The Chinese in Vancouver, 1945–80: The Pursuit of Identity and Power* (Vancouver: UBC Press, 1999).
9 Mar, *Brokering Belonging*.
10 In 1901, the City of Vancouver was a fraction of its current physical size, as its boundaries extended only from Burrard Inlet to 16th Avenue and from Clark Drive to Boundary Road. Not until January 1928 would the City achieve its current boundaries, with the agglomeration of the municipalities of Point Grey and South Vancouver.
11 Lee, "Road to Enfranchisement"; Ng, *Chinese in Vancouver*; Mar, *Brokering Belonging*.

There were 27 Chinese males to every one Chinese female (3,551 Chinese males and 130 Chinese females) and four Japanese males to every one Japanese female (1,776 Japanese males, 481 Japanese females) compared to a general population ratio of 1.5 males to every one female. These statistics reflect the sojourner experience of Chinese labourers working in Canada while remitting funds to China with the hopes of someday returning there. They are also the result of immigration restrictions such as the Chinese head tax (fifty dollars in 1885, one hundred in 1900, then five hundred in 1903) and the Hayashi-Lemieux Agreement of 1908, also known as the Gentlemen's Agreement, which restricted Japanese immigration to four hundred male Japanese immigrants and domestic servants per year—this curtailed the formation of families with children. A second generation of Canadian-born Chinese and Japanese would not appear on a large scale until the end of the Second World War. In the case of Chinese Canadians, population gender parity (the number of females equalling the number of males) would not occur until the early 1980s.[12]

In 1911, 82 per cent of the 19,568 Chinese who lived in British Columbia were outside of the City of Vancouver. The Chinese populations of Victoria (3,458) and New Westminster (3,006) were similar in size to that of Vancouver (3,559), but in these cities, the proportion of Chinese was higher: 11 per cent in Victoria and 26 per cent in New Westminster (compared to 3.5 per cent in Vancouver). And with 49 per cent of the Chinese population living outside of Vancouver, Victoria, and New Westminster, there is an opportunity for further research into the

Sign on wooden sidewalk along the 300 block of Cambie Street, ca. 1900. | Photo: Philip Timms. Vancouver Public Library, 78423

12 Peter S. Li, *Chinese in Canada*, 2nd ed. (Toronto: Oxford University Press, 1998).

contributions of these Chinese communities to the development of early British Columbia.[13]

In painting this demographic portrait of Chinese Canadians in early-twentieth-century Vancouver and British Columbia, it is important to acknowledge how this picture was created and who created it. While a deeper and more satisfactory examination of Canadian "census making" and "racial" categorization is beyond the scope of this piece, there are caveats to consider when using historical Census information.[14] As early as 1891, there were ongoing concerns over the accuracy of population counts in British Columbia, as "there are rumours of recounts, and in Victoria and in Vancouver, the city authorities claim that local returns show the population, in each instance, to be more by some thousands than is disclosed in the official calculations."[15] In this limited space, it is important to emphasize that Census identities were not necessarily claimed or self-identified by respondents, but could be assigned and defined by the Canadian state and its agents.

The Canadian Census is unique in that it is the only mandatory social survey conducted by the federal Canadian government for which a non-response can result in legal consequence. Since 1881, all census enumerators were required to take an oath of secrecy.[16] And until 1971, enumerators would go from dwelling to dwelling to collect responses. For the 1911 Census, enumerators were instructed to enter every house or building in "regular order" and count its residents in terms of

Shanghai Alley as depicted in a map of rail wards south of Pender Street, 1913. | *City of Vancouver Archives, 1972-582.08*

13 John Adams, *Chinese Victoria: A Long and Difficult Journey* (Victoria: Discover the Past, 2022); Lily Chow, *Chasing Their Dreams: Chinese Settlement in the Northwest Region of British Columbia* (Prince George: Caitlin Press, 2001); Lily Chow, *Sojourners in the North* (Prince George: Caitlin Press, 1996).
14 Bruce Curtis, *The Politics of Population: State Formation, Statistics, and the Census of Canada, 1840–1875* (Toronto: University of Toronto Press, 2001); Debra Thompson, *The Schematic State: Race, Transnationalism, and the Politics of the Census* (Cambridge: Cambridge University Press, 2016); Debra Thompson, "Race, the Canadian Census, and Interactive Political Development," *Studies in American Political Development* 34, no. 1 (2020): 44–70.
15 J.G. Colmer, *The Canadian Census* (n.p.: s.n., 1891).
16 "Chapter 2: Census History," *Guide to the Census of Population, 2016*, Statistics Canada, accessed April 4, 2021, https://www12.statcan.gc.ca/census-recensement/2016/ref/98-304/chap2-eng.cfm.

CENSUS MAKING AND CITY BUILDING — 157

"age, sex, social condition, religion, education, race and occupation." Interestingly, special attention was given to European birthplaces and the state of geopolitics in Europe at the time. As an example, enumerators were instructed to carefully document if a respondent was born in "British Islands," and "instead of Great Britain or British Isles, the particular country should be given, as England, Ireland, Scotland, Wales, Isle of Man, Channel Islands, Hebrides, Orkneys, Shetlands, etc."[17] Another example: for those born in Poland, as it "is no longer an independent country, inquiry should be made whether the birthplace was in what is now known as German Poland, or Austrian Poland, or Russian Poland, and the answer should be written accordingly as Germany (Pol.), Austria (Pol.), or Russia (Pol.)."[18] No such geographic or geopolitical considerations or courtesies toward shifting national borders were extended for any birthplaces in Asia or anywhere else in the world.

Enumerators were instructed to track racial origins through the respondent's father within a mélange of ethnic, national, religious, and racial identities.[19] A racial hierarchy with "English" at the apex was set: "a person whose father is English but whose mother is Scotch, Irish, French or other race will be ranked as English, and so with any of the others." The children "begotten of marriages between white and black or yellow races will be classed as Negro or Mongolian (Chinese or Japanese), as the case may be."[20]

Entries would be recorded using a set of published codes and entries written in cursive. From these individual population schedules, numbers

17 Census Office, *Fifth Census*.
18 Census Office, *Fifth Census*.
19 Examples include "English, Scotch, Irish, Welsh, French, German, Italian, Danish, Swedish, Norwegian, Bohemian, Ruthenian, Bukovinian, Galician, Bulgarian, Chinese, Japanese, Polish, Jewish, etc." In the case of "Indians" the origin is traced "through the mother, and names of their tribes should be given, as 'Chippewa,' 'Cree,' etc." (Census Office, *Fifth Census*).
20 Census Office, *Fifth Census*.

would be tabulated in Eastern Canada and the summaries published in a number of volumes at the provincial, district, and subdistrict levels by the Ministry of Agriculture, the federal department responsible for the Census in 1911. The veracity and accuracy with which enumerators captured the actual population is impossible to judge, yet the Census was highly dependent on the enumerators, as "to whom will be entrusted the actual work of the Census and upon whose judgement, discretion and intelligence the completeness and accuracy of it will to a very large degree depend."[21]

Enumerators were paid five cents per completed population schedule, each of which contained fifty records, with additional payment for expenses. To give perspective, the median clerical earnings per day for males in Canada in 1911 was sixty-eight cents.[22] A cursory review of original population schedule documents suggests that the quality of counts varied greatly from enumerator to enumerator. Some schedule entries for Chinese respondents were filled en masse, whereas other schedules were filled out diligently, record by record. A question emerges as to how many responses were carefully captured from respondents, and how many were hurriedly assigned by an enumerator compensated by the volume of responses he was able to acquire.

An incident published in the *Vancouver Daily World* on June 2, 1911, provides some insight into sociopolitical tensions within Vancouver's Chinese population while the 1911 Census was being conducted. Entitled "Chinese Give Census Takers Flat Refusal" with the subheading "No Savvee, No Talkee; Yesterday When the Enumerators Got Busy in Chinatown," the story reported how Chinese residents refused to answer

21 Census Office, *Fifth Census*.
22 Kris Inwood, Mary Pat Mackinnon, and Chris Minns, "Labour Market Dynamics in Canada, 1891–1911: A First Look From New Census Samples," in *The Dawn of "Canada's Century": The Hidden Histories*, ed. Gordon Darroch (Montreal: McGill-Queen's University Press, 2014).

the questions of Census takers or to admit them into residences or businesses. Enumerator James McKinney became so persistent when he was in Chinatown that he was confronted by a group of young (presumably Chinese) men, resulting in McKinney quitting his work and reporting the incident to Census Commissioner S. Des Brisay. In the article, Des Brisay was quoted: "Maybe [the Chinese] thought that there was another Chinese investigation in sight. Maybe they feared that they were all to be deported. At all events, we were turned down in Chinatown and were forced to seek the aid of the Chinese Consul General to Canada."[23] The "investigation" that Des Brisay was perhaps referring to was Mackenzie King's inquiry into the 1907 riots. A proclamation was subsequently issued by Chinese Consul General Dr. Chung (Cheung) Yee Bak, who was quoted as urging "my countrymen to extend all courtesy to Census officers. We have also communicated with the Chinese societies. They have taken the matter up and henceforth there will be no more difficulty." The article confirmed that from that day onward, the "cold attitudes" toward Census takers in Chinatown turned to ones of "kindness" and brought "the names of the Chinese on the Census roll."

Such an examination of the social, political, and cultural contexts of the 1901 and 1911 Censuses of the Chinese and Japanese populations in Vancouver shows that the 1907 riots were a reaction to the imagined number of Asians in Vancouver rather than the actual number. That they were an identifiable threat to the emerging white ethnic state and that British Columbia was a "White Man's Province"[24] was exemplified by the popular slogan of the time, "A White Canada Forever".[25] Measures of "race" in the 1901 and 1911 Censuses were an assemblage of identities,

▶

Boarded-up businesses at northwest corner of Carrall Street and Pender Street after 1907 race riots. | Photo: Philip Timms. Vancouver Public Library 940

23 "Chinese Give Census Takers Flat Refusal," *Vancouver Daily World*, June 2, 1911.
24 Roy, *A White Man's Province*.
25 Ward, *White Canada Forever*.

and notions of "race" were a shifting political and social construction, problematic rather than axiomatic, as opposed to a fixed, immutable biological constant.[26] It is of particular interest to note that there was no explicit "white" identity category that a Canadian Census respondent could claim.

Chinatown became a spatial shorthand and physical expression for the Chinese, illustrating the spatial divisions of the city along lines of class and race. Where some sociological and geographic literature has examined Chinatown as a "colony of the East in the West," others have examined "Chinatown as an idea" nested in cultural hegemony and white supremacy.[27] These scholastic traditions show how Chinatown is many things, depending on who is writing the story: a socioeconomic and cultural sanctuary; a neighbourhood of hope, struggle, and perseverance; as well as a place of immorality, a "celestial cesspool" defined by a moral panic. Chinatown was and is a site of resistance and resilience to economic, social, and political exclusion and marginalization.[28]

After the riots, Chinatown would continue to grow beyond Shanghai and Canton Alleys and Dupont (later Pender) Street. However, this growth was stopped in 1923 with the passing of the Chinese Immigration Act, the most comprehensive and regressive policy to restrict Chinese immigration to Canada. Over the following twenty-four years, a total of forty-four Chinese immigrants were allowed to enter the country.[29] It was only after the military participation of Chinese Canadians in the Second World War that Canada would acknowledge their contributions

26 Anderson, *Vancouver's Chinatown*.
27 David Chuenyan Lai, *Chinatowns: Towns Within Cities in Canada* (Vancouver: UBC Press, 1988); Anderson, *Vancouver's Chinatown*.
28 Harry Con and Edgar Wickberg, *From China to Canada: A History of the Chinese Communities in Canada* (Toronto: McClelland & Stewart et al., 1982); Paul Yee, *Saltwater City: An Illustrated History of the Chinese in Vancouver*, rev. ed. (Vancouver: Douglas & McIntyre, 2006).
29 "1923: The Federal Government Prohibits Chinese Immigration," Legislative Assembly of British Columbia, https://www.leg.bc.ca/dyl/Pages/1923-Federal-Government-Prohibits-Chinese-Immigration.aspx; Patricia E. Roy, *The Oriental Question: Consolidating a White Man's Province, 1914–41* (Vancouver: UBC Press, 2003).

to the country. This, along with lobbying by the Committee for the Repeal of the Chinese Immigration Act, formed by church and labour groups, was a significant factor contributing to that Act's repeal in 1947. Thereafter, Chinese men were allowed to bring their wives and children under the age of eighteen to Canada; the Chinese population would slowly begin to grow. Also, following the war, Canada finally began to lift some of the restrictions on who could be Canadian. However, until major revisions to Canadian immigration policy in the late 1960s, potential immigrants from Asia faced more restrictions than people coming from most other parts of the world.[30]

After postwar immigration reforms and repeal of explicitly racist immigration and exclusionary policies in the 1950s and 1960s, it became possible for some previously "bachelor" Chinese men to have families. Succeeding generations of Chinese Canadians would grow up with a different political and social consciousness, feeling that Vancouver was also their city and that they had as much of a right to it as others. As geographer David Harvey writes in "Right to the City," this is "not merely a right of access to what already exists, but a right to change it after our heart's desire."[31] Acts of explicit anti-Chinese racism—as in the 1956 housing discrimination case of Susan Chew—became newsworthy stories for the front pages instead of hidden matters of fact. The public ridicule of the New Westminster landlord and the ensuing resolution was declared as a "triumph of decency" in the same local newspaper that had advocated for the systematic exclusion of the Chinese a few decades earlier.[32]

30 Lee, "The Road to Enfranchisement"; Patricia E. Roy, *The Triumph of Citizenship: The Japanese and Chinese in Canada, 1941–67* (Vancouver: UBC Press, 2008).
31 David Harvey, "The Right to the City," *International Journal of Urban and Regional Research* 27, no. 4 (2003): 939–941.
32 "A Triumph of Decency," editorial, *The Province*, March 23, 1956, 6.

> **Argument**
>
> *advanced by*
>
> **Native Sons of British Columbia**
>
> **In Opposition to**
>
> **Granting**
>
> *of*
>
> **Oriental Franchise**
>
> JACKSON PRINTING CO., NEW WESTMINSTER, B. C.

By the 1950s, various levels of local, provincial, and federal governments would declare Vancouver's Chinatown and adjacent Strathcona neighborhoods as a "slum," and promise that "slum clearance" and "urban renewal" would provide salvation to the community. A multi-ethnic and multi-classed coalition of individuals and organizations in those neighbourhoods would successfully stop attempts to create an inner-city freeway, albeit with the loss of Hogan's Alley.[33] Community and professional organizations like the Strathcona Property Owners and Tenants Association; the Chinese Benevolent Association; and Birmingham & Wood Architects; grassroots activists such as Mary, Walter, and Shirley Chan; Ann Chan; Harry Con; Michael Harcourt; Bessie Lee; Sue Lum; Peter Oberlander; Foon Sien; Setty Pendakur; Bob Williams; Darlene Marzari; Joe and Hayne Wai; Walter Hardwick; Bing and Bonnie Thom; and many others would come together to resist the freeway. In what became known as the Freeway Debates, the community seeded the then radical idea that a great and sustainable North American city does not need to be built around the needs of automobiles; rather, urban planning should promote the ideals of community building and be based on the people and neighbourhoods it seeks to serve.[34]

Since its short history as a nation, Canada has developed into a multi-ethnic liberal democracy, even as it reconciles with its past and stumbles into the future. But how Canada counts and identifies its people is a civic project that must be subject to public scrutiny and debate, as even today, the Census is still haunted by an undercounting

[33] Crawford Kilian, *Go Do Some Great Thing: The Black Pioneers of British Columbia* (Madeira Park: Harbour Publishing, 2020); Adam Julian Rudder, *A Black Community in Vancouver? A History of Invisibility* (Victoria: University of Victoria, 2004).
[34] Michael Harcourt, Ken Cameron, and Sean Rossiter, *City Making in Paradise: Nine Decisions That Saved Vancouver* (Vancouver: Douglas & McIntyre, 2007); Daniel Francis, *Becoming Vancouver: A History* (Madeira Park: Harbour Publishing, 2021).

of racialized minorities.[35] Past Census data should not be summarily dismissed, but contextualized—not as a neutral, fixed truth, but as a reflection of an era's ideas and values about race, nation, and identity. Shining a light onto historical Census data reveals an inventory of archaic state practices, but also provides insight into how census making and city building can be re-evaluated to further the ongoing struggle for social justice and inclusion for all.

◀

Pamphlet by Native Sons of British Columbia, 1930. | *University of British Columbia Library, Chung Collection, Vancouver,* CC-TX-100-1-1

35 Raisa Patel, "Does Canada's Census Undercount Visible Minorities?," *Toronto Star*, July 15, 2021, https://www.thestar.com/politics/federal/2021/07/15/does-canadas-census-undercount-visible-minorities.html; Nick Boisvert and Raffy Boudjikanian, "Statistics Canada Exploring Changes to Census to More Accurately Reflect Canada's Diversity," *CBC*, July 17, 2021, https://www.cbc.ca/news/politics/statistics-canada-multiple-visible-minorities-1.6106571; *Visible Minority and Population Group Reference Guide, Census of Population, 2021*, Statistics Canada, accessed April 14, 2022, https://www12.statcan.gc.ca/census-recensement/2021/ref/98-500/006/98-500-x2021006-eng.cfm.

An Urban Rights Praxis of Remaining in Vancouver's Downtown Eastside

JEFFREY R. MASUDA, AARON FRANKS, AUDREY KOBAYASHI, TREVOR WIDEMAN, AND THE RIGHT TO REMAIN RESEARCH COLLECTIVE

Mike Maruno of the Asahi at bat on the Powell Street Grounds. | *Nikkei National Museum, Burnaby, 2010.26.20*

Vancouver's Downtown Eastside (DTES), situated on unceded, stolen Musqueam, Squamish, and Tsleil-Waututh lands, is home to the city's only remaining affordable neighbourhood, which houses thousands of people living on social assistance. For over a century, a succession of residents—Indigenous, Japanese Canadian, and Chinese Canadian, alongside psychiatric survivors, LGBTQ2S+ persons, people who use drugs, sex workers, and many others—have supported the tenuous hold on a diminishing housing stock still affordable to those on low income. Their perspectives shed light on over a hundred years of resistance and coalition building against colonization, demonstrating how a community can remain in place against wave after wave of dispossession from land, home, and culture in service to white supremacy.

This chapter is an abridged and updated journal article about historical inhabitance in the DTES that set the foundation for our continuing work as the Right to Remain Research Collective. The Collective is a multi-year joint initiative of neighbourhood organizations, single-room occupancy (SRO) tenants, and academic supporters committed to bringing history to life, documenting the rich, multilayered story of multiracial resistance that has protected what we refer to as a Right to Remain—the right to home, collective identity, culture, and political agency. Our participatory research has involved academics and

The Right to Remain team, October 2021. | Photo: Eliot Galán

residents of the DTES, as well as a range of allies, including artists, community advocacy groups, and community organizers. The original article reported on interviews with present and former inhabitants of the DTES, which revealed homologous narratives of abuse, struggle, and an enduring will to remain while articulating the shared needs, aspirations, and solidarity that dispel a dominant narrative of discontinuous succession in public and political discussion.

In this essay, we feature excerpts from living histories of dispossession and resistance spoken by those who have lived, suffered, struggled, lost, and remained—primarily people who live in or once lived in SRO hotels, nine-square-metre (hundred-square-foot) "sleeping rooms" without kitchens or bathrooms that still dominate the housing landscape of the neighbourhood. We interviewed young and old, those new to the neighbourhood, those who have spent a large part of their lives there, and those whose affiliation with the neighbourhood remains one of cultural connection and political solidarity.

We find that remaining connected to the DTES involves not only struggling for the material resources to meet basic needs, but also retaining existential, cultural, and political resources that are the foundations of community building and essential to a dignified urban life. These elements provide what we hope to be a convergence of community efforts to put a halt to white supremacist actions still active in the neighbourhood today in the form of illegal evictions, street sweeps, and other oppressive actions that pave the way for further SRO financialization and gentrification in the area.

"Should the Japanese Be Excluded from Canada?" poster for a debate in Ontario, 1908. | *University of British Columbia Library, Chung Collection, Vancouver, CC-TX-101-10*

MATERIAL REMAINING

A central part of the trauma experienced across successive generations of dispossessed racialized people in the area is the seemingly paradoxical positioning of the neighbourhood as a depository for an urban underclass while at the same time, there is a sustained assault on the material infrastructure that they have built up, time and again, to resource and house themselves. Japanese Canadians like Mrs. Kajiwara recall the discomfort and sacrifices made while living precariously in a prewar-built environment dominated by rooming houses—now referred to as SROs—originally built by Japanese immigrants. These were subsequently abandoned when Japanese Canadians, who in 1941 numbered more than eight thousand in the City of Vancouver, were uprooted, dispossessed, and interned during the Second World War. Among the dozens of these century-old buildings still standing, SROs still under private ownership currently house nearly four thousand DTES residents, albeit at escalating rents now well out of reach for those on inadequate housing assistance.[1]

Within the ever-diminishing SRO housing stock, some buildings have seen minimal upkeep and deterioration well beyond acceptable limits of habitability, in contrast to the trajectory of the community in the pre-1940s era, when Japanese Canadians built up the housing quality of the neighbourhood to the point that, by 1939, nearly half of all licensed housing was under the management of Japanese Canadians. Their forced expulsion—and the dispossession not only of ownership, but of the local economy—ensured this housing stock would be turned over to landlords, who over the years have sought to maximize profits

1 Jean Swanson, Lama Mugabo, King-Mong Chan, *Crisis: Rents and the Rate of Change in the Downtown Eastside*, Carnegie Community Action Project, 2017, https://www.readkong.com/page/ccap-2017-hotel-report-carnegie-community-action-project-9180074.

by keeping rooms in older buildings as small and partitioned as possible. For "Marty,"[2] the material disrepair directly undermined his sense of place: "The depression is brutal, it's terrible. You can't comfortably go to bed knowing you're going to be eaten alive by bedbugs. You walk in and, despite how clean you keep your room, there's cockroaches everywhere. It's demeaning. It's dehumanizing."

Other material resources also play an important role in supporting the community. For "Stephen," an Indigenous man experiencing chronic health difficulties from drug use, the density of resources made available through decades of built-up non-profit organizations and other supports for health and daily life originally drew him to the neighbourhood. For many people who have been placed in housing elsewhere in the city, this hub of services keeps them connected to the DTES. For them, not unlike Japanese Canadians before the 1940s, the neighbourhood is their only place to go. "Nancy," a Chinese senior, says, "Recently I just moved out, but I still come back here and do some studying, anything. I'm quite frequently around here." Physical proximity to appropriate services is extremely important to many people, often due to their poor health and reduced mobility, as well as the feelings of security, safety, and support that proximity and accessibility provide. "Chanel," who has been HIV positive for two decades, needs to be "close to my resources," and the DTES is thus "my only option ... my job, where I go to eat, to entertain, to visit."

Just as housing continues to disappear, so too do the resources that sustain life for people living in SROS. "Garrett," an Indigenous man and current low-income DTES resident, has observed that "most people down here, when they've paid their rent, they've only got ten, twenty

▶
Japanese Canadians being relocated to internment camps in the Interior of British Columbia, 1942. | Library Archives Canada, Ottawa, C-057250

2 Quotations indicate pseudonyms rather than participants' real names.

dollars left to their name." The situation of income scarcity—at the time of interviews, income for those on provincial housing allowance was as low as $375 a month—is compounded as cheap diners, pharmacies, and convenience stores leave the neighbourhood due to retail gentrification. For Audra, "It's just one thing after another that's just closing up. Cuts to programs and services have a real and life-changing impact on local residents." "Suzanne" testified to the potential impacts of cuts to services on Indigenous people like herself, stating, "I believe that if the programs don't keep getting their funding cut, other brothers and sisters down here are going to find hope and help like I did."

EXISTENTIAL REMAINING

Disproportionate levels of personal loss resulting from the structural violence of colonial and racist policies have led to a sense of existential silencing, erasure, and, ultimately, rupture and crisis. The uprooting of Japanese Canadians, for whom the neighbourhood was known as Paueru Gai, occurred with brutal efficiency. The first actions against Japanese Canadians immediately after the Pearl Harbor attack included imposing a curfew, banning items that the British Columbia Securities Commission considered potentially dangerous, cancelling insurance policies, firing people from their jobs, and rounding up Japanese nationals. Within several months, all people of Japanese ancestry were removed from coastal British Columbia. Paueru Gai was the last area to be cleared. Mr. Miyamoto talked in hesitant tones of the bewilderment, shame, terror, anger, and subsequent silence of the uprooting and dispossession. In a historical homology with the colonial dispossession of land, history, and culture inflicted upon Indigenous Peoples, this rupture from the material basis of the Japanese Canadian community's

origin, identity, cultural affinity, and political agency has lasted for generations. Asked about discussing leaving Paueru Gai with his parents, elder Frank Kamiya replied, "I don't think we really talked to our parents about things like that."

The multi-generational ripple effects of dispossession are not an inheritance only of those dispossessed in the past. The trauma has remained in place, flagging the long-term consequences of present-day dispossessions from the community by instilling a sense of self-censorship, at times, an acquiescence to injustice over long periods of time. But unlike Mr. Miyamoto's uprooting, the traumas inflicted by dispossession today tend to remain within, integral to the DTES. As low-income interviewee "Jane" recounted, the many ambiguities surrounding tenants' rights often manifest in ever more precarious housing, which ultimately leaves many unhoused. She recounts a friend who suddenly found himself forced into severe housing precarity in an SRO after the death of his tenancy-holding partner:

> [My friend's] partner had suddenly died, and [my friend] wasn't on the lease ... He had no personal resources. So within three months ... he was living in an SRO on Hastings, and it was like he didn't know what hit him ... 'cause he's grieving, and he's getting kicked out of his home at the same time.

Dispossession traumas are not only about residential status; they spill into the streets as a matter of daily life in the DTES. According to Glenn, some police intentionally target vulnerable people: "Drunks. Drug addicts. Elderly. Handicapped—if you got a cast on or a crutch, you're vulnerable."

The Balmoral Hotel in September 2018, a year after the building was condemned by the City of Vancouver. | *Photo: Angela May*

Violence to personhood is also covert, as described by "James" and "Iris," two Chinese Canadian seniors living in a Chinatown basement. They described a typical situation of constant threats in which "the basements are locked on the other side for the landlord, so the landlord can just come down whenever they want." They live "as if we're in prison." Such invisibilization is particularly dangerous for women, who experience physical and sexual violence as a matter of daily life, particularly in relation to sex work and homelessness. Women suffering violence reported being ignored or brushed off by police and by private security. As Audra told us, "I've had women tell me that they've been in the alley, they've been raped, and the police just drive by."

These double-edged assaults are made possible when state-authorized oppression targets the bodies, cultures, and spirits of racialized people living with housing inadequacy, many of whom have been precariously housed for more than a generation. While governments at all levels have since admitted their unjust complicity in the dispossession of Japanese Canadians from Paueru Gai, parallel dispossessions in the contemporary DTES continue to evade justice, despite their clear violation of established human rights, including their linkages to predatory capital.

CULTURAL REMAINING

Culture in the neighbourhood is not only derived from ethnicity, cultural hearth, and charity, but has been uniquely fostered from within, tied to a long legacy of organizing. From early Japanese Canadian citizenship activism;[3] to Depression-era worker protests in 1930;[4] to

3 Ken Adachi, *The Enemy That Never Was: A History of the Japanese Canadians* (Toronto: McClelland & Stewart, 1976).
4 Todd McCallum, *Hobohemia and the Crucifixion Machine: Rival Images of a New World in 1930s Vancouver* (Edmonton: AU Press, 2014); Richard McCandless, "Vancouver's 'Red Menace' of 1935: The Waterfront Situation," *BC Studies* 22 (1974): 56–70.

Chinese Canadian and women-led anti-slum-clearance efforts during the 1960s;[5] to many simultaneous grassroots efforts to support the recent national Missing and Murdered Indigenous Women and Girls movement; since the 1970s, the fight for social housing, harm reduction and drug decriminalization, sex workers' rights, and the protection of formal and informal mutual aids, supports, and resources continues.

Many interviewees recounted a culture of voluntarism in local non-profit advocacy and rights-based organizations. The PACE Society provides resources and advocacy for sex workers and is valued as more than just a place to acquire practical resources. "Chanel" says it's "so nonjudgmental and so easy ... it's an amazing space, and it's an important space." "Suzanne," a former resident and sex worker, felt a sense of responsibility and leadership to create a safe place for neighbours: "I realized some people don't have anybody at all, so I had to be that somebody for them." Or, as "Michael" says, "I more or less want to help the community, you know, to stay clean, to make it a better place to live."

"Michael's" sentiments are similar to those of Chinese Canadian seniors who emphasized the importance of establishing neighbourhood roots through community involvement. For "Florence," originally from China, the DTES is a place where, when it comes to activities in support centres, there is no distinction between the creative and supportive: "I love this here because ... we have a yearly festival, and I dance ... and we have a women's social issues discussion group at the women's centre."

For Japanese Canadians, the Powell Street Festival is rooted in a political movement begun by a small group of neighbourhood organizers during the 1977 centennial of the arrival of the first Japanese immigrant. Musician and activist Kazuo emphasized the cultural aspect of his own

5 Jo-Anne Lee, "Gender, Ethnicity, and Hybrid Forms of Community-Based Urban Activism in Vancouver, 1957–1978: The Strathcona Story Revisited," *Gender, Place & Culture* 14, no. 4 (2007): 381–407.

roots, citing the forty-year-old sakura (ornamental cherry) trees planted in Oppenheimer Park. He explains how these trees have served as living emblems of the historical presence of Japanese Canadians:

> In the Issei [first-generation immigrant] heart and mind ... that's a symbol as long as the sakura exists. The temple is still there, the language school is still there. But they are not as visible in terms of connecting to our roots, but the sakura flowers have always been in our minds as fond memories of the Issei.

Interviewees reported that mutual understanding has existed between Japanese Canadian and Indigenous activists for decades, even if tenuously so, based on shared experiences of political persecution and cultural repression. As Japanese Canadian elder and long-time rights advocate Grace Eiko Thomson eloquently described, there is a shared sense of responsibility and respect for the neighbourhood as a sacred space to both communities.

POLITICAL REMAINING

Politics in the DTES are double sided. The neighbourhood is characterized as simultaneously repulsive and attractive, a refuge and a trap, a site of containment and of opportunity. Accompanying these dualities is the sense that the DTES is itself a fluid place; Paueru Gai, East Van, the East Side, Chinatown, Strathcona, and Powell Street are more than street-bound cartographic designations. They are vernacular monikers that describe an overlapping sense of place. For the Japanese Canadian elders we interviewed, efforts to contain people or problems within prescribed boundaries of a few blocks around Powell Street hearken

back to the area's racist history of ghettoization. When pressed, elders like Mr. Nimi strongly refused to romanticize the bonds of community and the marking of a "Japanese" area as anything more than a survival tactic in the face of exclusion by white society.

This reading of an enforced ghettoization was further projected by some to hold true for the current low-income residents of the DTES. Comparing their struggles to her own community's, Grace Eiko Thomson suggested that "the people here are imprisoned because they are not allowed to live full lives." Experiences of interviewees such as "Florence" confirm parallel experiences of place-based stigmatization and the stripping of agency:

> If you look for a job, when people ask, Where do you live? you tell them Dunlevy Street. And then you see no reply, even if you have a good education, even if you are good people ...

Activism in the DTES is a place-based expression for anti-racist and anti-colonial urban politics that transcend the local defence of territory, property, or resources. Despite the history of racial ghettoization, both past and present residents have embraced the neighbourhood's identity as a "poor area" without embarrassment and even with pride. According to Frank Kamiya, "The community sort of did stick together in the earlier days. I guess we felt more comfortable that way." "Garrett" reflects that the power of the DTES "is because it is a real community ... You know, even though there's so much chaos, everybody knows everybody, right?"

Some even asserted the right to be poor and to remain human, a "citizen," an equal. The entwined senses of community and political agency are a crucial asset intimately tied to people's choice to remain—or not—in place. Long-time resident Tom insisted, "It should be our

right to remain, I mean, it was always a poor person's neighborhood." This sense of belonging, ownership, and the right to be respected is also articulated by "Jane" as being more readily realized at the local level than in the wider city: "I think I've got the right to the neighbourhood. but I'm certainly aware that I don't have the right to the city as a whole." Set against multiple abuses, dispossessions, and indignities, both recent and lifelong residents expressed a positive vision of a preference to remain in the neighborhood. Wendel, a Chinese Canadian elder who has resided in the area for five years, feels that "people who remain here who would like to continue to remain here. They can find a way to still keep the connection in this neighbourhood."

THE WORK AHEAD

The Right to Remain Research Collective continues the work to advance these four elements of collective rights—material, existential, cultural, and political—in support of the in situ SRO tenant movement. Focused squarely on the (de)housing crisis precipitated by decades of structural neglect of SRO housing stock, we seek to re-narrate the history of these buildings and of the people who have inhabited them—to confront dominant narratives of neglect, blame, and vilification often cast upon them from outside and above in order to make way for a more grounded narrative of political remaining that is the lasting legacy of the Downtown Eastside. While living in presently inhumane and ever-deteriorating living conditions, these inhabitants past and present demonstrate time and time again the basic humanity that runs deep in the neighbourhood that is the heart and soul of a wayward city.

ACKNOWLEDGMENTS

360 RIOT WALK

360 Riot Walk was created by the terrific production team of Arian Jacobs and Adiba Muzaffar, who shot the footage for the tour stops on an Insta360 ONE camera. They also colourized and composited over a hundred archival photographs and documents into the 360 photographs and designed the navigation and interaction for various visual and audio elements using Pano2VR editing software. Sean Arden and Maria Lantin at the Basically Good Media Lab provided invaluable advice, guidance, and the fancy equipment needed to make the project happen. Laura Saimoto and Darius Maze at the Japanese Language School and Japanese Hall were consistently generous with assistance for the guided tours and providing space for the invaluable post-tour discussions.

 I would like to thank Michael Barnholden for co-writing the script and for the many 1907 Riot walking tours he led for so many years prior to this project, as well as Deanna Chan, Rika Uto, Doris Chow, Ellen Kim, Catherine Clement, the Grant family, June Chow, Phinder Dulai, Zoe Lam, Elwin Xie, Hayne Wai, John Atkin, Kirk Tougas, Alex Hass, Hanif Janmohamed, Jai Djwa, Rina Liddle, Mimi Gellman, Irene He, Naiya Tsang, Jean Kamimura, and Donna Wong. Thanks to the Arsenal Pulp Press team, especially Brian Lam, Jazmin Welch, and Catharine Chen for their contributions, professionalism, and clarity of vision. Special thanks to Debbie Cheung for her steadfast support from *RIOT FOOD HERE* to now. And extra special thanks to Emiko Morita for her sage advice, critical acumen, uncanny insight, and common sense.

RIOT FOOD HERE

I am grateful to Chef Kris Barnholden for contributing the delicious and fresh food with creative flourishes that we plied unsuspecting passersby with; Stephan Wright for technical design and fabrication; Alex Hass for her evocative design work; and Michael Barnholden for the project's inaugural walking tour, which stimulated

the genesis of what would become *360 Riot Walk*. I would also like to thank Larry Grant, Cease Wyss, Charan Gill, Kevin Huang, Harvey Chiang, Phinder Dulai, Hayne Wai, Lisa Uyeda and Linda Reid, Rika Uto, Doris Chow, Hollie McKeil, Cluny McPherson, Ellen Kim, Cindy Mochizuki, Diana Freundl, Keely Bruce, Naiya Tsang, Sahali Tsang, Rina Liddle, Adrian Sinclair, Theresa Wong, Debbie Cheung, and Emiko Morita.

RIOT FOOD HERE was presented as part of *Ten Different Things*, a series of public art commissions in Vancouver curated by Kate Armstrong that engaged ten artists to investigate the role of culture as a critical ingredient in the construct and vitality of the contemporary city. Project partners included the Carnegie Community Centre, Oppenheimer Park Fieldhouse, and Dr. Sun Yat-Sen Classical Chinese Garden.

THE UNWELCOME DINNER

The Unwelcome Dinner was really the brainchild of Tyler Russell of Centre A: Vancouver International Centre for Contemporary Asian Art, to whom I am grateful for the opportunity to develop a project that was as intellectually stimulating as it was socially and delightfully delicious. I am also indebted to Natalie Tan and Centre A's team of tireless volunteers; to Chefs Wesley Young and Jacob Deacon-Evans, for their curiosity and culinary acumen; to guest speakers Hayne Wai, Stephanie Yuen, and Kevin Huang; to Roedde House Museum; and for her support, insight and patience, Emiko Morita.

WORKS CITED

Adachi, Ken. *The Enemy That Never Was: A History of the Japanese Canadians*. Toronto: McClelland & Stewart, 1976.

Adams, John. *Chinese Victoria: A Long and Difficult Journey*. Victoria: Discover the Past, 2022.

Anderson, Kay. *Vancouver's Chinatown: Racial Discourse in Canada, 1875–1980*. Montreal and Kingston: McGill-Queen's University Press, 1991.

Atkinson, David C. *The Burden of White Supremacy: Containing Asian Migration in the British Empire and the United States*. Chapel Hill: University of North Carolina Press, 2016.

Ayukawa, Michiko Midge. *Hiroshima Immigrants in Canada, 1891–1941*. Vancouver: UBC Press, 2008.

Buchignani, Norman, Doreen M. Indra, and Ram Srivastiva. *Continuous Journey: A Social History of South Asians in Canada*. Toronto: McClelland & Stewart, 1985.

Census Office, Department of Agriculture. *Fifth Census of Canada 1911: Instructions to Chief Officers, Commissioners and Enumerators*. Ottawa: Government Printing Bureau, 1911.

Census Office, Department of Agriculture. *Fourth Census of Canada 1901: Instructions to Chief Officers, Commissioners and Enumerators*. Ottawa: Government Printing Bureau, 1901.

Chang, Kornel. *Pacific Connections: The Making of the U.S.-Canadian Borderlands*. Oakland: University of California Press, 2012.

Chen, Zhongping. "The Construction of the Canadian Pacific Railway and the Transpacific Chinese Diaspora, 1880–1885," in *The Chinese and the Iron Road: Building the Transcontinental Railroad*, edited by Gordon H. Chang and Shelley Fisher Fishkin, 294–313. Stanford: Stanford University Press, 2019.

Chow, Lily. *Chasing Their Dreams: Chinese Settlement in the Northwest Region of British Columbia*. Prince George: Caitlin Press, 2001.

Chow, Lily. *Sojourners in the North*. Prince George: Caitlin Press, 1996.

Colmer, J.G. *The Canadian Census*. N.p.: s.n., 1891.

Con, Harry, and Edgar Wickberg. *From China to Canada: A History of the Chinese Communities in Canada*. Toronto: McClelland & Stewart in association with the Multiculturalism Directorate, Department of the Secretary of State, and the Canadian Government Publishing Centre, Supply and Services Canada, 1982.

Curtis, Bruce. *The Politics of Population: State Formation, Statistics, and the Census of Canada, 1840–1875*. Toronto: University of Toronto Press, 2001.

Francis, Daniel. *Becoming Vancouver: A History*. Madeira Park: Harbour Publishing, 2021.

Franks, Aaron, Andy Mori, Ali Lohan, Jeff Masuda, and the Right to Remain Community Fair Team. "The Right to Remain: Reading and Resisting Dispossession in Vancouver's Downtown Eastside with Participatory Art-Making." *feral feminisms* 4 (2015): 43–50.

Government of British Columbia. *An Act to Prevent Chinese from Acquiring Crown Lands, February, 18, 1884*. Chung Collection, University of British Columbia Library.

Harcourt, Michael, Ken Cameron, and Sean Rossiter. *City Making in Paradise: Nine Decisions That Saved Vancouver*. Vancouver: Douglas & McIntyre, 2007.

Harvey, David. "The Right to the City." *International Journal of Urban and Regional Research* 27, no. 4 (2003): 939–941.

Inwood, Kris, Mary Pat Mackinnon, and Chris Minns. "Labour Market Dynamics in Canada, 1891–1911: A First Look from New Census Samples." In *The Dawn of "Canada's Century": The Hidden Histories*, edited by Gordon Darroch, 361–395. Montreal: McGill-Queen's University Press, 2014.

Izumi, Masumi. "Reclaiming and Reinventing 'Powell Street': Reconstruction of the Japanese Canadian Community in Post–World War II Vancouver." In *Nikkei in the Pacific Northwest: Japanese Americans and Japanese Canadians in the Twentieth Century*, edited by Louis Fiset and Gail M. Nomura, 308–334. Seattle: University of Washington Press, 2005.

Jensen, Joan M. *Passage from India: Asian Indian Immigrants in North America*. New Haven: Yale University Press, 1988.

Kilian, Crawford. *Go Do Some Great Thing: The Black Pioneers of British Columbia*. Madeira Park: Harbour Publishing, 2020.

King, William Lyon Mackenzie. *The Diaries of William Lyon Mackenzie King*. Ottawa: Library and Archives Canada, 2006.

Knight, Rolf. *Indians at Work: An Informal History of Native Indian Labour in British Columbia, 1858–1930*. Vancouver: New Star, 1978.

Knight, Rolf. *Indians at Work: An Informal History of Native Indian Labour in British Columbia, 1858–1930*. 2nd ed. Vancouver: New Star, 1996.

Kobayashi, Audrey. *Memories of Our Past: A Brief History and Walking Tour of Powell Street*. Vancouver: NRC Publishing, 1992.

Lai, David Chuenyan. *Chinatowns: Towns Within Cities in Canada*. Vancouver: UBC Press, 1988.

Lai, David Chuenyan. *The Forbidden City Within Victoria: Myth, Symbol, and Streetscape of Canada's Earliest Chinatown*. Victoria: Orca Book Publishers, 1991.

Lee, Carol F. "The Road to Enfranchisement: Chinese and Japanese in British Columbia." *BC Studies* 30 (1976): 44–76.

Lee, Jo-Anne. "Gender, Ethnicity, and Hybrid Forms of Community-Based Urban Activism in Vancouver, 1957–1978: The Strathcona Story Revisited." *Gender, Place & Culture* 14, no. 4 (2007): 381–407.

Li, Peter S. *Chinese in Canada*. 2nd ed. Toronto: Oxford University Press, 1998.

Malik, Anushay. "South Asian Canadians and the Labour Movement in British Columbia." In *A Social History of South Asians in British Columbia*, edited by Satwinder Kaur Bains and Balbir Gurm, 256–277. Abbotsford: University of the Fraser Valley, 2022.

Mar, Lisa Rose. *Brokering Belonging: Chinese in Canada's Exclusion Era, 1885–1945*. New York: Oxford University Press, 2010.

Masuda, Jeffrey R., Aaron Franks, Audrey Kobayashi, and Trevor Wideman. "After Dispossession: An Urban Rights Praxis of Remaining in Vancouver's Downtown Eastside." *Environment and Planning D: Society and Space* 38, no. 2 (2019): 43–50.

McCallum, Todd. *Hobohemia and the Crucifixion Machine: Rival Images of a New World in 1930s Vancouver*. Edmonton: AU Press, 2014.

McCandless, Richard. "Vancouver's 'Red Menace' of 1935: The Waterfront Situation." *BC Studies* 22 (1974): 56–70.

McDonald, Robert A.J. *Making Vancouver: Class, Status and Social Boundaries, 1863–1913*. Vancouver: UBC Press, 1996.

Morita, Katsuyoshi. *Powell Street Monogatari*. Burnaby: Live Canada Publishing Ltd., 1989.

Ng, Wing Chung. *The Chinese in Vancouver, 1945–80: The Pursuit of Identity and Power*. Vancouver: UBC Press, 1999.

Nikkei National Museum & Cultural Centre. *Revitalizing Japantown? A Unifying Exploration of Human Rights, Branding, and Place*. Burnaby: Nikkei National Museum & Cultural Centre, 2015.

Omi, Michael, and Howard Winant. *Racial Formation in the United States: From the 1960s to the 1990s*. New York and London: Routledge, 1994.

Roy, Patricia E. *The Oriental Question: Consolidating a White Man's Province, 1914–41*. Vancouver: UBC Press, 2003.

Roy, Patricia E. *The Triumph of Citizenship: The Japanese and Chinese in Canada, 1941–67*. Vancouver: UBC Press, 2008.

Roy, Patricia E. *A White Man's Province: British Columbia Politicians and Chinese and Japanese Immigrants, 1858–1914*. Vancouver: UBC Press, 1989.

Rudder, Adam Julian. *A Black Community in Vancouver? A History of Invisibility*. Victoria: University of Victoria, 2004.

Thompson, Debra. "Race, the Canadian Census, and Interactive Political Development." *Studies in American Political Development* 34, no. 1 (2020): 44–70.

Thompson, Debra. *The Schematic State: Race, Transnationalism, and the Politics of the Census*. Cambridge: Cambridge University Press, 2016.

Thomson, Grace Eiko. *Chiru Sakura—Falling Cherry Blossoms: A Mother & Daughter's Journey Through Racism, Internment and Oppression*. Prince George: Caitlin Press, 2021.

Ward, W. Peter. *White Canada Forever: Popular Attitudes and Public Policy Towards Orientals in British Columbia*. Montreal and Kingston: McGill-Queen's University Press, 1990.

Wideman, Trevor J., and Jeffrey R. Masuda. "Toponymic Assemblages, Resistance, and the Politics of Planning in Vancouver, Canada." *Environment and Planning C: Politics and Space* 36, no. 3 (2018): 383–402.

Wideman, Trevor James, and Jeffrey R. Masuda. "Assembling 'Japantown'? A Critical Toponymy of Urban Dispossession in Vancouver, Canada." *Urban Geography* 39, no. 4 (2018): 493–518.

Yakashiro, Nicole. "'Powell Street Is Dead': Nikkei Loss, Commemoration, and Representations of Place in the Settler Colonial City." "Loss and the City," special issue, *Urban History Review* 48, no. 2 (2021): 32–55.

Yee, Paul. *Saltwater City: An Illustrated History of the Chinese in Vancouver*. Vancouver: Douglas & McIntyre, 1988.

Yee, Paul. *Saltwater City: An Illustrated History of the Chinese in Vancouver*. Rev. ed. Vancouver: Douglas & McIntyre, 2006.

Young, Charles H., and Helen R.Y. Reid. *The Japanese Canadians*. Toronto: University of Toronto Press, 1938.

Yu, Henry. "Global Migrants and the New Pacific Canada." *International Journal* 64, no. 4 (2009): 1011–1026.

FURTHER READING

Aitken, Douglas Cameron. *Three Faces of Vancouver: A Guide to First Nations, European and Asian Vancouver.* Vancouver: Lions Gate Road, 2009.

Barnholden, Michael. *Reading the Riot Act: A Brief History of Riots in Vancouver.* Vancouver: Anvil Press, 2005.

Bird, Kate. *City on Edge: A Rebellious Century of Vancouver Protests, Riots, and Strikes.* Vancouver: Greystone Books, 2017.

Chan, Anthony B. *Gold Mountain: The Chinese in the New World.* Vancouver: New Star Books, 1993.

Chang, Kornel. "Circulating Race and Empire: Transnational Labor Activism and the Politics of Anti-Asian Agitation in the Anglo-American Pacific World, 1880–1910." *Journal of American History* 96, no. 3 (2009): 678–701.

Chapleau, J.A., and John Hamilton Gray. *Report of the Royal Commission on Chinese Immigration: Report and Evidence.* Ottawa: Printed by order of the Commission, 1885.

Clute, Roger Conger. *Report of the Royal Commission on Chinese and Japanese Immigration.* Session 1902. Ottawa: S.E. Dawson, 1902.

Creese, Gillian. "Exclusion or Solidarity? Vancouver Workers Confront the 'Oriental Problem.'" *BC Studies* 80 (1988/89): 24–51.

Davis, Chuck. *The Chuck Davis History of Metropolitan Vancouver.* Madeira Park: Harbour Publishing, 2011.

Franks, Aaron, Jeffrey Masuda, Audrey Kobayashi, and the Right to Remain Community Fair Team. "Mobilising the 'Right to Remain' in Vancouver's Paueru-gai: An Art-Based Participatory Research Intervention." In *Public Art Encounters: Art, Space and Identity*, edited by Martin Zebracki and Joni M. Palmer, 141–160. Abingdon: Routledge, 2016.

Henderson Publishing. *Henderson's Vancouver City Directory for 1907.* Vancouver: Henderson Publishing, 1907.

Iino, Masako. "Japan's Reaction to the Vancouver Riot of 1907." *BC Studies* 60 (1983/84): 28–47.

Jarvis, Robert. *The Workingman's Revolt: The Vancouver Asiatic Exclusion Rally of 1907.* Toronto: Citizens for Foreign Aid Reform, 1991.

Kalman, Harold, and Robin Ward. *Exploring Vancouver: The Architectural Guide.* Vancouver: UBC Press, 1993.

King, William Lyon Mackenzie. *Report on the Need for the Suppression of the Opium Traffic in Canada.* Ottawa: S.E. Dawson, 1908.

King, William Lyon Mackenzie. *Royal Commission Appointed to Investigate Methods by Which Oriental Labourers Have Been Induced to Come to Canada.* Ottawa: S.E. Dawson, 1908.

King, William Lyon Mackenzie. *Royal Commission to Investigate Losses by the Chinese Population of Vancouver, British Columbia, on the Occasion of the Riots in That City in September, 1907*. Ottawa: S.E. Dawson, 1908.

King, William Lyon Mackenzie. *Royal Commission to Investigate Losses by the Japanese Population of Vancouver, British Columbia, on the Occasion of the Riots in That City in September, 1907*. Ottawa: S.E. Dawson, 1908.

Kruger, Angela. "Remaining in Death: A Critical Ethnography of Death, Remains, and Community in Vancouver's Downtown Eastside." Master's thesis, Queen's University, 2019. https://qspace.library.queensu.ca/handle/1974/26685.

Lee, Erika. "Hemispheric Orientalism and the 1907 Pacific Coast Race Riots." *Amerasia Journal* 33, no. 2 (2007): 19–47.

Leier, Mark. *Where the Fraser River Flows: The Industrial Workers of the World in British Columbia*. Vancouver: New Star Books, 1989.

Macdonald, Bruce. *Vancouver: A Visual History*. Vancouver: Talonbooks, 1992.

Masuda, Greg, director. *The Right to Remain*. Vancouver: Masuda Media, 2015. Film.

Masuda, Jeffrey R., and Sonia Bookman. "Neighbourhood Branding and the Right to the City. *Progress in Human Geography* 42, no. 2 (2018): 165–182.

McCulloch, Scott. "Reimaging Urban Space: The Festival as a (Re)branding Vehicle for Inscribing Vancouver's Downtown Eastside as Japantown." Master's thesis, University of Manitoba, 2014. https://mspace.lib.umanitoba.ca/xmlui/handle/1993/30142.

Ogden, Johanna. "White Right and Labor Organizing in Oregon's 'Hindu' City." *Oregon Historical Quarterly* 120, no. 4 (2019): 488–515.

Price, John. *Orienting Canada: Race, Empire, and the Transpacific*. Vancouver: UBC Press, 2011.

Price, John. "'Orienting' the Empire: Mackenzie King and the Aftermath of the 1907 Race Riots." *BC Studies* 156/157 (2007/08): 53–81.

Smedman, Lisa. *Immigrants: Stories of Vancouver's People*. Vancouver: Vancouver Courier, 2009.

Stanger-Ross, Jordan, ed. *Landscapes of Injustice: A New Perspective on the Internment and Dispossession of Japanese Canadians*. Montreal: McGill-Queen's University Press, 2020.

Sugimoto, Howard Hiroshi. *Japanese Immigration, the Vancouver Riots, and Canadian Diplomacy*. New York: Arno Press, 1978.

Thirkell, Fred, and Bob Scullion. *Philip Timms' Vancouver: 1900–1910*. Surrey: Heritage House, 2006.

Waite, Donald E. *Vancouver Exposed: A History in Photographs*. Maple Ridge: Waite Bird Photos, 2010.

Wardhaugh, Robert. "The 'Impartial Umpire' Views the West: Mackenzie King and the Search for the New Jerusalem." *Manitoba History* 29 (1995): 11–22.

Wickberg, Edward. "Chinese and Canadian Influence on Chinese Politics in Vancouver, 1900–1947." *BC Studies* 45 (1980): 37–55

Wideman, Trevor. "(Re)assembling 'Japantown': A Critical Toponymy of Planning and Resistance in Vancouver's Downtown Eastside." Master's thesis, Queen's University, 2015. https://qspace.library.queensu.ca/handle/1974/13706?show=full.

Wynne, Robert E. "American Labor Leaders and the Vancouver Anti-Oriental Riot." *Pacific Northwest Quarterly* 57, no. 4 (1966): 172–179.

INDEX

Note: Page numbers in italics indicate an illustration or photograph

360 Riot Walk (walking tour): about, 9, 23, 25, 29–30, 59; accessibility considerations, 38; community partners, 27; credits, 107; guided tours, 41–43; impetus for, 30–31, 49; inclusion of archival photographs and historical documents, 39, 41; language and translation considerations, 32–33, 35; map and route, *34*, 35–36; photographs, *22*, *36*, *37*, *38*, *43*, *60*, *106*, *120*; research and writing process, 31–32; safety considerations, 39; technology considerations, 36, 38, 39. *See also* anti-Asian riots (Vancouver, 1907)

360 Riot Walk script, 62–104; Stop 1: Maple Tree Square, Gastown, *62*, 62–65, *64*; Stop 2: Carrall and East Hastings streets, *28*, *66*, 66–67, *67*; Stop 3: 139 East Hastings Street, *68*, 68–70, *69*; Stop 4: Main Street, *71*, 71–73, *72*; Stop 5: Westminster and Dupont streets (Main and Pender), *74*, 74–76, *75*; Stop 6: West Pender and Carrall streets, *77*, 77–80, *78*; Stop 7: Shanghai Alley, *81*, 81–84, *84*; Stop 8: East Pender and Columbia streets, *85*, 85–87, *86*; Stop 9: Across from 122 Powell Street, *88*, 88–91, *91*; Stop 10: 245 Powell Street, *92*, 92–95, *94*; Stop 11: 374 Powell Street, *96*, 96–98, *97*; Stop 12: Alexander Street, 400 block (Japanese Language School), *40*, *99*, 99–100; Stop 13: Powell Street Grounds (Oppenheimer Park), *101*, 101–5, *104*, *105*

Alexander, Richard, 65, 99
Alexander Street, 92, 99
Annual Women's Memorial March, 57
anti-Asian racism and violence: ACLA activism against, 111–13; against Chinese in Vancouver, 65, 77, 87, 99, 151; against Japanese in Vancouver, 93; contemporary presence of, 21, 25, 109; COVID-19 pandemic and, 21, 25, 55, 110–11, *112–13*; economic, moral, and racial justifications, 14–16; gentrification as, 144; institutional and political exclusion, 82, 109, 153–54; on Pacific Coast (1907–08), 134–38. *See also* Asiatic Exclusion League
anti-Asian riots (Vancouver, 1907): aftermath, 19–20, 102; Asiatic Exclusion League public demonstration, 16–17, 73; blame for, 80; causes, 14–16; Census data and, 160; in Chinatown, 5, 17, 19, 74, 79, 80, 83, *161*; Chinese and Japanese responses, 17–19, *18*, 81–82, 88, 90; on Powell Street, *16*, 17, 19, 88–90, *89*, 93, 95, 100, *127*; *RIOT FOOD HERE* and, 49, 49–55, *51*, *53–54*, *56*, *58*. *See also 360 Riot Walk* (walking tour)
anti-Chinese riot (Seattle, 1886), 67
anti-Chinese riot (Vancouver, 1887): about, 11, 44–45, 65, 151; *The Unwelcome Dinner* curated dinner and, 45–47, *46*
Armstrong, Kate, 49
Asahi baseball team, 90, 101, *166*

Asian Canadian Labour Alliance (ACLA), 111–13
Asiatic Exclusion League: *360 Riot Walk* and, 25; 1907 anti-Asian riot and, 16–17, 73; advertisements for, *24*, *30*; BC chapter, 16, *17*, 71, 73; Bellingham riot and, 131–32; chapters along West Coast, 67; in Everett, WA, 136; *RIOT FOOD HERE* and, 49; San Francisco anti-Asian violence and, 134
Atkinson, David, 129
augmented reality (AR), 36, 38
Australia, 14

Balmoral Hotel, *174*
Barnholden, Kris, 50, *53*
Barnholden, Michael, 31, 49. *See also 360 Riot Walk* (walking tour)
BC Electric Railway, 11, 66–67
Beatty Street Drill Hall, 49, *52*
Bellingham Herald, *130*
Bellingham riot (1907), 26, 70, 129–30, 130–32, 139
Bethune, Alexander, 73, 93, 102
Birmingham & Wood Architects, 164
Black community: 1907 anti-Asian riots and, 76, 80; arrival in BC, 65; COVID-19 pandemic and, 110–11; Hogan's Alley, 76, 144, 164; racism against in Vancouver, 82, 93
Black Lives Matter movement, 55, 114
Blaine (WA), 131
Bows and Arrows (trade union), 80
Bowser, William, 70
British Columbia, 11, 70, 153
Brixton Flats (303 East Pender Street), 142, *144*

Brown, E. (major), 49, 73
Burrard Inlet, 63

Cambie Street Grounds (now Larwill Park), 35, 49, 73
Canadian Illustrated News, 32
Canadian Pacific Railway (CPR), 11, 11n2, 80, 153
Canton Alley, 80, 81, 141
Cantonese Opera troupe, Le Wan Nian, *154*
Capilano Indian Reserve, 80
Carnegie Community Centre, 27, 32, 41
Carrall Street: Chinatown and, 11; East Hastings and, *28*, *66*, 66–67, *67*; West Pender and, 77, *77*, *78*, 152
Census of Canada: about, 26, 149, 151, 164–65; 1901 Census, 13n10, 151, 154; 1911 Census, 13n10, 151, 154–56; Chinese community and, 159–60; enumerator instructions and accuracy concerns, 156, 158–59; ethno-cultural and racial attitudes within, 151, 153, 160, 162
Chan, Ann, 164
Chan, Mary, 164
Chan, Shirley, 164
Chan, Walter, 164
Chee Kung Tong Chinese Freemasons Building, 77
Cheng, Shu Ren (Arthur): *Snapshots of History* mural, 145
Chew, Susan, 163
Chinatown: about, 26; *360 Riot Walk* and, 42; 1907 anti-Asian riots and, 5, 17, 19, 74, 79, 80, 83, *161*; activism against development projects, 21, 144–45, *145*, *146*, 163–64; Canton Alley, 80, 81, 141; COVID-19 pandemic

and, 145, 147; establishment, 11, 141; gentrification, 21, 42, 141, 142, 144; resilience of, 142, 145, 147; *RIOT FOOD HERE* and, 55; Shanghai Alley, 81, *83*, *157*; as symbol, 121, 162. See also *360 Riot Walk* (walking tour); Chinese community; Downtown Eastside
Chinatown Cares Grocery Delivery Program, 147
Chinatown Memorial Monument, 145
Chinese Benevolent Association, 87, 102, 164
Chinese Canadian Historical Society of BC, 27, 32
Chinese community: 1885 expulsion from Bellingham, 131; 1887 anti-Chinese riot in Vancouver, 11, 44–45, 65, 151; 1901 and 1911 Census and, 154–56, 159–60; anti-Chinese sugar advertisement, *148*; arrival in BC, 11, 11n2, 153; Chinese Immigration Act (1923), 20, 30, 82, 104, 142, 162; discrimination against in Vancouver, 65, 77, 87, 99, 151; fish peddlers, *10*; gender imbalance, 155; head tax, 14, 16, 20, 82, 85, 87, 104, 141–42, *142*, 155; immigration restrictions lifted, 162–63; labour sharks, 85, 87; outside of Vancouver, 155–56; sense of belonging, 163; Tacoma handbill against, 135. See also anti-Asian racism and violence; anti-Asian riots (1907); Chinatown
Chinese Cultural Centre, 145
Chinese Empire Reform Association, 87
Chinese Immigration Act (1885), 82. See also head tax, Chinese
Chinese Immigration Act (Chinese Exclusion Act, 1923), 20, 30, 82, 104, 142, 162

Chinook Jargon, 45, 100
Chow, Peter, 76
Chow, Philip, 76
Chow, Yucho, 74, 76
Chung (Cheung) Yee Bak, 160
City Hall (former location at Old Market Hall), 35, 49, 71, *137*
Committee for the Repeal of the Chinese Immigration Act, 162
Con, Harry, 164
Continuous Journey Regulation, 19–20, 104
Cordova Street, 92
Cotterill, Frank, 80
COVID-19 pandemic: anti-Asian violence and, 21, 25, 55, 110–11, *112–13*; Chinatown and, 145, 147

Daily Hive, 120
Danville (WA), 135
data, 149. See also Census of Canada
Deacon-Evans, Jacob, 44, 45, 47
Deighton, John "Gassy Jack," 57
Derrida, Jacques, 33
Des Brisay, S. (commissioner), 160
dinners, curated: *Orange County*, 44, *44*, 47; *RIOT FOOD HERE*, 49, 49–55, *51*, *53–54*, *56*, *58*; *The Unwelcome Dinner*, 45–47, *46*, 48. See also restaurants
dispossession traumas, 172–74
diversity, 114
Downtown Eastside (DTES): about, 21, 26, 167–68; access to resources, 170, 172; activism in, 174–75, 177; assault on housing, 169–70; City of Vancouver's Downtown Eastside Plan (2015), *122*, *124*; community involvement, 175–76; desire to belong and remain, 177–78; dispossession traumas, 173–74; enforced ghettoization and, 176–77; gentrification and revitalization, 125–26; homelessness crisis, 57; Market Alley, 35–36; Right to Remain

Research Collective, 167, *168*, 178; *RIOT FOOD HERE* and, 52; single-room occupancy (SRO) housing, 57, 168, 169–70, 173, 178; Skid Road, 13, 42–43, 52. See also Chinatown; Powell Street (Paueru Gai)
Dr. Sun Yat-Sen Classical Chinese Garden, 27, 32, 41, 49
drugs, war on, 36, 102
Dunlevy Street, 9, 96
Dupont Street. See Pender Street

East Hastings Street, 66–67, 68
East Indians. See South Asian community
East Pender Street. See Pender Street
EMBERS, 43
Equity, Diversity, and Inclusion (EDI), 114–15
European settlers, 63, 65
Everett (WA), 135–38
Everett Daily Herald, 138
extremism, right-wing, 116–17

False Creek, 11, 63, 77
Fire Dragon Festival, 147
First Nations. See Indigenous Peoples
Fongoun (tailor), 85
food. See dinners, curated; restaurants
Fowler, A.E., 73, 80, 131–32
Franks, Aaron: *Revitalizing Japantown?* research project (with Kobayashi and Masuda), 125–26
Fraser River, 14, 63
Freedom Convoy, 116
Freeway Debates, 21, 144, 164
Fuji Chop Suey House, 98

Gastown, 35, 42, 57, 62–63
gender imbalance, 154–55

Gentlemen's Agreement (Hayashi-Lemieux Agreement), 19, 104, 155
gentrification: in Chinatown, 21, 42, 141, 142, 144; in Downtown Eastside, 57, 172; on Powell Street, 123, 125–26
Ghadar Movement, 113
Goldstone Bakery, 145
Gore Avenue, 144
Grand Trunk Pacific Railway, 70
Great Depression, 101–2
Great Vancouver Fire (1886), 65, *150*

Harcourt, Michael, 164
Hardwick, Walter, 164
Harper's Weekly, 108
Harvey, David, 163
Hastings Mill, 9, 11, *12*, 13, 100
Hastings Street, 66–67, 68
Hawaii, immigration from, 19–20, 63, 70, 100
Hayashi-Lemieux Agreement (Gentlemen's Agreement), 19, 104, 155
head tax, Chinese, 14, 16, 20, 82, 85, 87, 104, 141–42, *142*, 155
hənq̓əmin̓əm̓ (Indigenous language), 23, 33
histories, knowing your own, 113
Hogan's Alley, 76, 144, 164
housing (homelessness) crisis, 57, 102, 173. See also single-room occupancy (SRO) housing
Hua Foundation, 47
Huang, Kevin, 47

immigration: 1907 anti-Asian Vancouver riots and, 15–16; 1907 Bellingham riot and, 130, 139; Asian exclusion, 14–15, 70, 104, 153; Chinese head tax, 14, 16, 20, 82, 85, 87, 104, 141–42, *142*, 155; Chinese Immigration Act (Chinese Exclusion Act, 1923), 20, 30, 82, 104, 142, 162; Continuous Journey

Regulation, 19–20, 104; migrant neighbourhoods, 120–21; political cartoon, *15*; postwar reforms, 162–63
inclusion, 114
indentured labour, 85, 87
India, immigration from, 16, 20. *See also* South Asian community
Indigenous Peoples: Alexander Street beach encampment, *8*; in Bows and Arrows union, 80; displacement in Vancouver, 9; Downtown Eastside and, 122; Equity, Diversity, and Inclusion (EDI) and, 114–15; at Hastings Mill, 9; hənq̓əminəm̓ (language), 23, 33; K̲'emk̲'eláy̓ seasonal camp, 100; as longshoremen, 9, 100; Luk'luk' seasonal camp, 62–63; in Powell Street Ground (Oppenheimer Park), 101; Skwx̱wú7mesh Sníchim (language), 23, 33. *See also* səlilwətaɬ (Tsleil-Waututh) Nation; Skwx̱wú7mesh (Squamish) Nation; xʷməθkʷəy̓əm (Musqueam) Nation
Industrial Workers of the World, 80

Japan, 14, 16, 19, 104
Japan-Canada Trust Savings Company, 96
Japanese community: 1901 and 1911 Census and, 13n10, 154–55; 1907 anti-Asian riots and, 17, 19, 88–90, *89*, 93, 95, 100; Asahi baseball team, 90, 101, *166*; discrimination against, 93; Downtown Eastside and, 169, 175–76; gender imbalance, 155; Hayashi-Lemieux Agreement (Gentlemen's Agreement), 19, 104, 155; immigration and exclusion, 14, 16, 19, 70, 90, 104, *169*; internment during Second World War, 20, 42, 98, 104, 122–23, 169, *171*; perceptions of, 92; Powell Street Festival, 27, 41, 43, 175; violence against in Blaine, 131; violence against in San Francisco, 134. *See also* Powell Street (Paueru Gai)
Japanese Language School and Japanese Hall, 27, 32, *40*, 41, 42, 100
Japantown. *See* Powell Street (Paueru Gai)
Jones, Newton, 136, 137
justice, 114

Kajiwara, Mrs., 169
Kamiya, Frank, 173, 177
Kanakas, 63, 100
Kazuo (musician and activist), 175–76
Keller, George Frederick: anti-Chinese illustration, *111*
K̲'emk̲'eláy̓ (seasonal Indigenous camp), 100
King, William Lyon Mackenzie, 20, 36, 102, 104, 160
Knights of Labour, 65
Kobayashi, Audrey: *Revitalizing Japantown?* research project (with Masuda and Franks), 125–26

labour movement (unions), 80, 113–14, 115–17, 134, 136
labour sharks, 85, 87
Lao Tzu (Laozi) mural (313 East Pender Street), 142, *143*
Larwill Park (formerly Cambie Street Grounds), 35, 49, 73
Laurier, Wilfrid, 19, 20
Lee, Bessie, 164
Lee Association Building, 142
Lee Shing Dok, *142*
Lemieux, Rodolphe, 19
Le Wan Nian Cantonese Opera troupe, *154*
Listman, George P., 80
Live Oak (CA), 138

Local Area Planning Process (Vancouver), 125–26
longshoremen, 9, 100
Luk'luk' (seasonal Indigenous camp), 62–63
Lum, Sue, 164

MacLean, Malcolm, 151
Main Street (formerly Westminster Avenue), 11, 71, 74, 92
Maple Tree Square, 62
Mar, Lisa, 154
Market Alley, 35–36
Marshall, Scott M., 137
Maruno, Mike, *166*
Marzari, Darlene, 164
Masuda, Jeff: *Revitalizing Japantown?* research project (with Kobayashi and Franks), 125–26
Matsuno-yu (bathhouse), 96
McKinney, James, 160
meals. *See* dinners, curated
Miyamoto, Mr., 172
model minority myth, 112
Mori, Andy T., 122
Morikawa, M. Kishiro, 93
Musqueam (xʷməθkʷəy̓əm) Nation, 9, 23, 31, 62–63. *See also* Indigenous Peoples
Muzaffar, Adiba, 36

Nahanee, William, 100
names, harm from, 125–26, 126–27
Nast, Thomas: anti-Chinese cartoon, *108*
Native Sons of British Columbia pamphlet, *164*
neighbourhoods, migrant, 120–21
New Westminster, 155
New World Hotel (Tamura Building), 96
Nimi, Mr., 177

Oberlander, Peter, 164
Old Market Hall (formerly City Hall), 35, 49, 71, *137*

Omi, Michael, 153
oolichan, 63
opium, 15, 87, 102
Opium Act (1908), 36
Oppenheimer Park (formerly Powell Street Grounds), 49, 55, 57, 93, 101–2, 176
Orange County (video installation and curated dinner), 44, *44*, 47

PACE Society, 175
Pantages, Alexander, 68
Pantages Theatre, 68, 73
Pekin Chop Suey House, 77
Pelly, Bernard, 136
Pendakur, Setty, 164
Pender Street (formerly Dupont Street): Brixton Flats (303 East Pender Street), 142, *144*; Carrall and West Pender, 77, *77*, 78, *152*, *161*; Chinatown established at, 11; Columbia and East Pender, 85, *85*–87, *86*; Lao Tzu (Laozi) mural (313 East Pender Street), 142, *143*; Westminster (Main) and, *74*, 74–76, *75*
photography: Yucho Chow's studio, 74, 76
Pioneer Place (Pigeon Park), 66
police violence, 173–74
Powell, Israel Wood, 127
Powell Street (Paueru Gai): about, 13, 21, 26, 92, 119, 1907 anti-Asian riots and, *16*, 17, 19, 88–90, *89*, 93, 95, 100, *127*; enforced ghettoization and, 176–77; expulsion of Japanese community during Second World War, 98, 122–23, 172–73; gentrification and revitalization, 21, 123, 125–26; "Japantown" name, 119–20, 121–23, 125, 127; photographs, *16*, *89*, *93*, *95*, *102*, *103*, *118*, *127*; "Powell Street" name, 127; in Vancouver's Downtown Eastside Plan (2015), 122, *124*. *See also 360 Riot Walk* (walking tour);

Downtown Eastside; Japanese community
Powell Street Festival, 27, 41, 43, 175
Powell Street Grounds (now Oppenheimer Park), 49, 55, 57, 93, 101–2, 176
Puget Sound American (newspaper), *128*
Punjabi workers. *See* South Asian community

race and racial formation, 14, 153
racism: vs. Equity, Diversity, and Inclusion (EDI), 114–15; fighting for racial justice, 115, 117; institutional racism, 82, 109, 153–54; in labour movement, 113; public awareness and action against, 55, 57; right-wing extremism and, 116–17; voting and, 155. *See also* anti-Asian racism and violence
restaurants, 77, 93, 98, 134. *See also* dinners, curated
revitalization. *See* gentrification
Revitalizing Japantown? research project (Masuda, Kobayashi, and Franks), 125–26
Right to Remain Research Collective, 167, *168*, 178
RIOT FOOD HERE, 49, 49–55, *51*, 53–54, *56*, *58*
Roedde House Museum, 45, *45*
Roy, Patricia E.: *A White Man's Province*, 25
Russell, Tyler, 44–45

San Francisco, 134
San Francisco Illustrated Wasp, *111*
Sasaki family, 96, 98
#SaveChinatownYVR, 145, 145n3
Seattle, 67, 134–35
Second World War, Japanese internment, 20, 42, 98, 104, 122–23, 169, *171*
The Secret Life of Canada (CBC podcast), 120

səlilwətaʔɬ (Tsleil-Waututh) Nation, 9, 23, 31, 62–63, 65. *See also* Indigenous Peoples
Shanghai Alley, 81, *83*, *157*
Shikatani, Gerry, 44
Sien, Foon, 164
Sikhs. *See* South Asian community
Silver Bow Trades and Labor Assembly and Butte Miners' Union, *133*
Sing Kew Chinese Theatre, 81
single-room occupancy (SRO) housing, 57, 168, 169–70, 173, 178
Skid Road, 13, 42–43, 52
Sḵwx̱wú7mesh (Squamish) Nation, 9, 23, 31, *45*, 62–63. *See also* Indigenous Peoples
Sḵwx̱wú7mesh Sníchim (Indigenous language), 23, 33
South Asian community: arrival in Vancouver, 26; Bellingham riot against, 70, 130–31, *132*; Danville violence against, *135*; Everett violence against, 135–38; labour activism in BC, 113; Live Oak violence against, 138; Seattle violence against, 134–35; ss *Komagata Maru*, 104; violence against in Washington state, *128*, 129
Squamish (Sḵwx̱wú7mesh) Nation, 9, 23, 31, *45*, 62–63. *See also* Indigenous Peoples
ss *Komagata Maru*, 104
ss *Kumeric*, 70
Stamp, Edward, 100
Stanley Park, 100, *101*
St. John, John, 80
Strathcona Property Owners and Tenants Association (SPOTA), 144, 164
sugar advertisement, anti-Chinese, *148*
Sun Yat-Sen, 77, 81

Tacoma, anti-Chinese handbill, *135*
Takahashi family, 96

Tamura, Shinkichi, 96
Tamura Building (New World Hotel), 96
Tamura Trading Company, 96
Ten Different Things (public art commissions series), 49
Thom, Bing, 164
Thom, Bonnie, 164
Thomson, Grace Eiko, 176, *177*
360 Riot Walk. *See 360 Riot Walk* (walking tour); *360 Riot Walk* script
translation, 33
Tsleil-Waututh (səlilwətaʔɬ) Nation, 9, 23, 31, 62–63, 65. *See also* Indigenous Peoples

unions (labour movement), 80, 113–14, 115–17, 134, 136
United States of America, 14. *See also* Bellingham riot; Danville (WA); Everett (WA); Live Oak (CA); San Francisco; Seattle
The Unwelcome Dinner (curated dinner), 45–47, *46*, *48*

Vancouver: 1901 and 1911 Census data, 151, 154–56; Chinese Canadian sense of belonging, 163; city boundaries, 154n10; City Hall (former location at Old Market Hall), 35, 49, 71, *137*; contemporary challenges, 57; establishment and first election (1886), 65, 151; Freeway Debates, 21, 144, 164; Great Vancouver Fire (1886), 65, *150*; institutional racism, 82; Local Area Planning Process, 125–26. *See also 360 Riot Walk* (walking tour); anti-Asian riots (1907); anti-Chinese riot (Vancouver, 1887); Chinatown; Chinese community; Downtown Eastside; Japanese community; Powell Street (Paueru Gai)
Vancouver Daily Province, 18, 24, 30, 80, 82, 88

Vancouver Daily World, 30, 81, 159
Vancouver Trades and Labour Council, 16, 29, 71
Victoria, 155
voluntarism, 175
voting, sign encouraging, *155*

Wai, Hayne, 47, 164
Wai, Joe, 164
Washington, 129. *See also* Bellingham riot; Danville (WA); Everett (WA); Seattle
Westminster Avenue (now Main Street), 11, 71, 74, 92
West Pender Street. *See* Pender Street
Whatcom County (WA), 132
White Canada Crusade (pamphlet), 20
white supremacy, 31, 41, 114, 116, 139, 168
Williams, Bob, 164
Winant, Howard, 153
Wing Sang Building, 77
Wing Sang Company, 87
women, 19, 31, 77, 110–11, 113, 174
World War II, Japanese internment, 20, 42, 98, 104, 122–23, 169, *171*
Wright, Stephan, 52

xʷməθkʷəy̓əm (Musqueam) Nation, 9, 23, 31, 62–63. *See also* Indigenous Peoples

Yan, Andy, 44
Yarrow Intergenerational Society for Justice, 145
Yip Sang, 77, 80, 85, 87
Young, C.O., 136
Young, Wesley, 44, 45, 47
Youth Collaborative for Chinatown, 145
Yuen, Stephanie, 47

zones of exclusion, 144. *See also* gentrification

ABOUT THE CONTRIBUTORS

MICHAEL BARNHOLDEN is the author of *Reading the Riot Act: A Brief History of Riots in Vancouver*, ten books of poetry, several non-fiction titles, including *Circumstances Alter Photographs*, and a translation of *Gabriel Dumont Speaks* by Gabriel Dumont. His editorial work includes *Writing Class: The Kootenay School of Writing Anthology*, Roy Miki's *Flow*, and Garry Thomas Morse's *Scofflaw*.

PAUL ENGLESBERG is a retired education professor who taught at Walden University and Western Washington University, where he directed the Asian American Curriculum and Research Project. He is currently writing a book about immigrants, racism, and conflict in the Pacific Northwest, focusing on the arrival of several hundred workers from Punjab, India, and their forced expulsion from Bellingham and Everett, Washington, in 1907.

AARON FRANKS is a Senior Manager at the First Nations Information Governance Centre, a non-profit mandated by the Assembly of First Nations, and was previously a researcher with the Centre for Environmental Health Equity and the Centre for Indigenous Research Creation at Queen's University.

STEPHANIE FUNG (she/her) has organized tenants and workers since 2015. Her love for community organizing started in Chinatown, Vancouver, where she fought against gentrification alongside working-class Chinese seniors.

AUDREY KOBAYASHI is a Distinguished Professor Emerita in the Department of Geography and Planning, Queen's University. She has published extensively in the areas of human rights and activism, anti-racism, immigration, human geography theories, and the historical geographies of Japanese Canadian communities.

ANNA LIU (she/her) is an executive board member of the Asian Canadian Labour Alliance, Ontario. She is a union organizer and holds an MA in labour studies.

MELODY MA 馬勻雅 is a community organizer and neighbourhood advocate for Vancouver's Chinatown. She led a campaign called #SaveChinatownYVR that helped defeat a controversial development project proposed at 105 Keefer. In 2018, she coordinated the Chinatown Summer Events series as a way for the community to reclaim space. Melody is also a writer on urban issues, and her opinion pieces have appeared in *The Tyee*, the *Toronto Star*, the *Vancouver Sun*, *The Georgia Straight*, and the *Globe and Mail*.

JEFFREY R. MASUDA is a *Sansei* (third-generation) Japanese Canadian settler scholar, presently located onləkʷəŋən lands at the University of Victoria. He is a founding member of the Right to Remain Research Collective, working to support the grassroots tenant movement in Vancouver's Downtown Eastside. Jeff is a professor of Public Health and Social Policy and a human geographer by training.

ABOUT THE CONTRIBUTORS — 191

ANGELA MAY is a writer, artist, activist, and PhD candidate in English and Cultural Studies at McMaster University, studying the politics of trauma, pain, and loss in Powell Street and the Downtown Eastside.

KARINE NG 吴珏颖 (佢/she) is a K–12 public school teacher and an active member of the Anti-Oppression Educators Collective and the Vancouver Elementary and Adult Educators' Society.

CHRIS RAMSAROOP (he/him) is an organizer with Justice for Migrant Workers (J4MW) and teaches at the University of Toronto and the University of Windsor.

The **RIGHT TO REMAIN COLLECTIVE** includes academic researchers and trainees, housing organizers, and tenants living in SROs in the Downtown Eastside of Vancouver. Since 2016, its purpose has been to lend research in support of a multiracial tenants' rights movement for decolonized, dignified, healthy, and sustainable housing futures in the neighbourhood.

PATRICIA E. ROY is a professor emerita of history at the University of Victoria and an authority on anti-Asian policies in British Columbia. She is best known for her trilogy of books on responses to Chinese and Japanese immigrants: *A White Man's Province* (1989); *The Oriental Question* (2003), and *The Triumph of Citizenship* (2007).

TREVOR WIDEMAN is a postdoctoral fellow at the Centre for Criminology & Sociolegal Studies at the University of Toronto. Previously a research assistant with the Centre for Environmental Health Equity, his current work seeks to understand how urban planning mediates the politics of private property and how unconventional conceptions of land use might arise to reallocate power in the city.

NICOLE YAKASHIRO is a PhD student in the UBC Department of History, studying settler colonialism, race, and property relations in twentieth-century British Columbia.

ANDY YAN is an urban planner, adjunct professor, and director of the City Program at Simon Fraser University. His specializations include urban regeneration, applied demographics, geographic information systems, neighbourhood development, public outreach, social media, and quantitative research.

Photo: Emiko Morita

HENRY TSANG is a visual and media artist based on the unceded territories of the xʷməθkʷəy̓əm (Musqueam), Sḵwx̱wú7mesh (Squamish), and səl̓ilwətaʔɬ (Tsleil-Waututh) Nations. His projects explore the spatial politics of history, language, community, food, and cultural translation in relationship to place, taking the form of gallery exhibitions, pop-up street food offerings, 360 video walking tours, curated dinners, and ephemeral and permanent public art and employing video, photography, language, interactive media, and convivial events.

Henry has worked with Vancouver's Chinese Cultural Centre and artist-run centres to produce curatorial projects such as *Self Not Whole: Cultural Identity and Chinese-Canadian Artists in Vancouver* (1991), *Racy Sexy* (1993), and *City at the End of Time: Hong Kong 1997* (1997). He is a past recipient of the VIVA Award and is an associate professor at Emily Carr University of Art + Design in Vancouver, Canada.

henrytsang.ca